MILNER CRAFT SERIES

Bullion Stitch Embroidery

FROM ROSES TO WILDFLOWERS

JENNY BRADFORD

SALLY MILNER PUBLISHING

First published in 1991 by
Sally Milner Publishing Pty Ltd
558 Darling Street
Rozelle NSW 2039 Australia

Reprinted 1991 (three times), 1992 (twice), 1993 (twice)

© Jenny Bradford 1991

Cover and colour design by David Constable
Layout by Doric Order
Photography by Andre Martin
Typeset in Australia by Asset Typesetting Pty Ltd
Printed in Australia by Impact Printing

National Library of Australia
Cataloguing-in-Publication data:

Bradford, Jenny, 1936-
 Bullion stitch embroidery.

 ISBN 1 86351 040 0.

 1. Embroidery — Patterns. I. Title.

746.4404

ACKNOWLEDGEMENTS

The constant interest, enthusiasm and encouragement given to me by the many people I meet throughout the year are the greatest incentive anyone could have to continue writing and producing new ideas.

Special thanks to Jackie Kelly, Doreen Smith and Jean Wilson, all of whom have so generously shared with me their knowledge and expertise in bullion embroidery and made personal contributions to this book.

I am indebted to Veronica Henry of Cotton On Creations, Mittagong, NSW 2575, for donating all the silk threads used for working the samples for the book.

A very big thank you to all those who combine their individual talents to produce this book, Sally Milner and her team of experts, Andre Martin for his superb photography and my son Terry for his help in preparing the manuscript.

Finally to my ever patient and supportive husband Don whose contribution to my books is increasing with every publication. His meticulous attention to detail both in his drawings and the correction of my manuscript plays a very large part in the success of my books.

Jenny Bradford, 1990.

DEDICATED

To the memory of my father, who taught me to love, appreciate and observe the beauty of the world around us.

CONTENTS

INTRODUCTION

Bullion stitch embroidery is a form of embroidery that holds a fascination for many people whether they are dedicated embroiderers or not. Tiny bullion roses are loved for the special finishing touch they can add to handmade garments and gifts.

This book is designed to introduce the beginner to this fascinating form of embroidery. Step by step instructions, from the type of fabrics, threads and needles, through to detailed instructions of how to work bullion stitch and how to arrange the stitches to create many different flowers, are given.

For those already familiar with bullion stitch I hope the many and varied ways of using it will open up new possibilities to extend their skills.

Full size patterns are given where applicable, with detailed instructions for projects and illustrated designs.

MATERIALS

Embroidery is a creative and sensual thing; it is a time-consuming activity done primarily for enjoyment rather than monetary gain. It is therefore important that you gain pleasure and satisfaction while working a piece as well as from the finished item. A large part of this satisfaction comes not only from the choice of the project but also the fabric and threads used.

THREADS

The choice of threads available for this type of work is ever increasing as the overall range of embroidery threads on the market steadily grows.

Many people tend to stick to the threads they are most familiar with and have readily available, usually stranded cottons. Unfortunately these are not the easiest threads to use for bullion stitch and as a result many become frustrated because they find it almost impossible to produce an evenly wrapped bullion stitch.

I find the easiest way to work bullion stitch is with a single strand of firmly twisted thread. The single strand must be heavy enough to produce the desired texture and, preferably, be smooth and silky in order to slide with the least resistance. The use of a single strand thread eliminates the possibility of any unevenness in the bullion wrap due to an uneven combination of several strands of thread. The choice of a smooth silky thread results in reduced resistance, making it easier to pull the needle through the wraps and tighten the stitch more smoothly.

Taking these factors into consideration it will be obvious that the choice of thread will play a very important part not only in the look of the embroidery but also in the ease and speed at which one can work. A low resistance smooth silk thread is far less likely to result in aching fingers than a high resistance thread such as a low sheen cotton.

Conversely when working other embroidery stitches, particularly colonial knots, the slippery threads are harder to handle and it is much easier to maintain an even tension when using low sheen, high resistance threads. With this in mind I strongly recommend varying the type of threads used on any one project to give the best results.

Just as important as any of the previous comments is the fact that you choose a thread to work with that you enjoy handling.

The choice is yours, not that of a teacher or so-called expert. The following list is a guide to some of the threads that can be used. I urge you to experiment and try as many as you can, particularly if you are a beginner, so that you can form your own opinions and make your selections accordingly.

Remember that the thickness of the thread chosen will govern the size of the finished flowers. Use fine threads for delicate work, heavy threads for bold designs.

KANAGAWA SILK THREADS

High sheen, low resistance thread.

These threads come in various thicknesses and are quite lovely to use (attractively packaged and sealed with cellophane against dust and damage). The No. 16 silk thread (buttonhole twist) is, in my opinion, the easiest thread of all to use for bullion stitch. The colour range is not as large as some of the other threads listed, but I have found it quite adequate for the projects illustrated in this book. All the Kanagawa range consist of very firmly twisted high sheen threads which I find less prone to catching and snagging than some other silk threads.

- No. 16 silk thread (buttonhole twist) (Referred to throughout as Kanagawa 1000)
 Available in over 200 colours conveniently packaged in 20 metre lengths on neat easily stored cards. One strand is equivalent to approximately three strands of stranded cotton.
- 'Silk Stitch'
 Available in 80 colours and packaged on 50 metre reels, it can also be used for machine embroidery. One strand is equivalent to approximately two strands of stranded cotton.
- 'No 50'
 This thread is very fine. Mainly intended for machine embroidery it comes on reels, 100 metres per reel. It is useful for embroidering the centres of flowers. One strand is equivalent to approximately one strand of stranded cotton.

OTHER QUALITY SILK THREADS

Also available are the 'Au Vere a Soie' range. All threads are attractively packaged in tiny plastic bags for protection against dust and damage.

- Soie D'Algere
 Stranded silk, medium sheen, medium resistance. Sold in 2 gram hanks.

 This seven strand thread is available in a wide range of beautiful colours. A single strand is slightly thicker than a strand of stranded cotton and is strong enough to be used individually for very fine work.
- Soie Gobelins
 Sold on 50 metre reels, it is a high sheen, twisted single strand thread, easy to use and good for fine work. The available colour range may be limited.
- Soie Perle
 Also sold on 50 metre reels, it is a heavier thread similar to Soie Gobelins.

COTTON THREADS

Stranded cotton, low sheen and high resistance, is a popular choice because of the wide colour range, cost, availability and versatility. Any number of strands can be used to vary the thickness of the stitches.

COTTON PERLE, NOs 3, 5, 8 AND 12.

A high sheen, low resistance thread. The colour range is more limited than stranded cotton. Variation in thickness (No 3 is the thickest thread) makes it worth considering.

CROCHET COTTONS

Many produce very even bullion stitch. They are strong and hardwearing and can work well for single colour flowers on items such as towels.

KNITTING COTTON

There are various weights and types available. Some are high sheen, firmly twisted and easy to use. They wash well and are excellent for work on towelling items where bulk is sometimes important.

WOOLS

Knitting wool, tapestry wool and other embroidery wools can all be used. The more firmly twisted ones will normally give better results.

RAYON AND SYNTHETIC THREADS

There are many of these available but some people find them difficult to use because of the static properties common to most of these threads.

Marlitt thread is a four strand thread with a very high sheen. One to four strands are used according to the thickness required.

Ribbon Floss is another very high sheen, heavy synthetic thread which may be used for this type of embroidery.

Shiny machine embroidery threads such as Isafil and Madera threads are excellent for very fine centres to flowers. Work in a hoop, use a very fine straw needle and maintain a tight tension to keep the thread under control and the tension even.

NEEDLES

Straw needles (sometimes called millinary needles) are, as far as I am concerned, the best needles to use for bullion work.

A straw needle has an extra long shaft and an eye consistent in width with the shaft. The long shaft accommodates the wraps of a bullion stitch more easily and the lack of enlargement at the eye of the needle means it can be pulled through the wraps smoothly. The only restriction on the use of a straw needle is the size of the eye, which can be difficult to thread with the heavier threads.

Chenille needles are the best option when the chosen thread is too thick for a straw needle. They have a large eye, a short shaft and a sharp point.

See notes on individual stitches for the best needles to use for specific techniques.

FABRIC

Almost any fabric is suitable for this type of embroidery. The main criterion to be considered is that the fabric chosen is substantial enough to support the weight and density of the embroidery. For example canvas is used for the cottage garden picture in preference to an even weave linen, to give sufficient support to the dense embroidery design. Careful consideration of these factors make it easier to achieve a professional finish to your work.

The weight and texture of the fabric chosen will govern the choice of threads to be used. A fine delicate fabric will need a fine thread. A heavy textured fabric, such as towelling or velvet, will require a much heavier thread in order to give the embroidery sufficient bulk to stand out. The daisy design shown on the robe featured in the colour pages is worked in knitting cotton and is bold enough to stand out well on the rough texture of the towelling. The same daisies are used on strips of cotton batiste in the baby quilt (page 47), worked in Kanagawa 1000 silk thread, and on silk dupion on the lid of the powder bowl (page 40), worked in Silk Stitch. Embroidered in these finer threads the daisies become more delicate in shape and form.

EMBROIDERY HOOPS

Much of this embroidery can be worked without the use of a hoop, however, certain stitches, for example colonial knots and long, couched bullion stitches, are easier to work if the fabric is held taut in a hoop.

If the hoop is to be hand-held, make sure you use the smallest practicable hoop. If it is necessary to use a large hoop try to use one on a stand to leave both hands free to manipulate the needle.

TRANSFERRING A DESIGN ONTO FABRIC

Water erasable and fadeable pens are very useful for marking the main features of a design on to the fabric. Remember to use the lightest touch possible to avoid marking the fabric too heavily. Restricting the design marks to the heaviest areas of embroidery will also ensure that these marks will be well hidden on the finished work. A double-ended water erasable pen is now available, with a fine tip at one end and a bold tip at the other.

Chalk pencils used for dressmaking are useful on dark fabrics. Make sure that they are well sharpened to give good results.

Transfer pencils are available and should be used according to manufacturer's instructions.

An easy way to transfer the main design lines of a pattern to all types of fabric is to photocopy or trace the lines onto paper. Position the design on the fabric carefully and machine, using matching thread and a long stitch, or tack by hand using a small stitch, along the lines through the paper and fabric. Carefully tear away the paper and embroider over the guidelines. This stitching may be removed once the outline has been embroidered but in most cases it will not show once the design has been completed.

CARE OF BULLION EMBROIDERY

This type of embroidery is very hard wearing and it washes well. Washing instructions applicable to the most delicate fibres should be followed. For example, if silk thread is used on cotton I would wash the item as for silk. Similarly if cotton thread is used on silk fabric then silk washing instructions would also apply.

IRONING

Bullion embroidery is raised embroidery and therefore care should be taken to avoid unnecessary flattening of the design. One of the most satisfactory ways of ironing this type of embroidery is to lay it face down on a towel and press on the wrong side.

HELPFUL HINTS FOR LEFT-HANDED STUDENTS

There are far more left-handed people around than there used to be and I think that teachers of embroidery can no longer ignore this so-called 'problem'. It takes time and concentration for a right-handed teacher to be able to demonstrate for left-handed students. Fortunately I find students very patient and appreciative of efforts to understand their problems and it can be very worthwhile to try to master the techniques their way.

The following points may help both teachers and students to reverse the techniques described in the following pages.

- Remember that not only is the needle held in the opposite hand but the direction of the thread must be altered as well. For example if a right-hander has the thread on the left of the needle then the left-hander must put the thread to the right of the needle.

- If the right-handed worker is working from left to right, either in a straight line or a circle (clockwise), the left-hander will work from right to left in a line or circle (anti-clockwise).

- Starting positions for left-handers are normally opposite to those for right-handers.

- Try using a mirror positioned as shown in the diagram to convert the diagrams to show left-handed techniques.

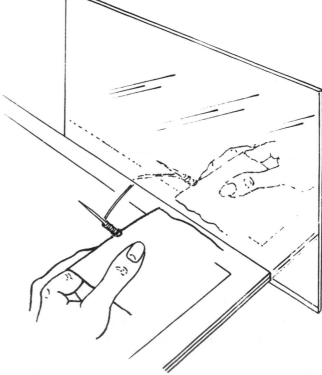

STITCHES

BULLION STITCH

This stitch needs practice to achieve perfect results! Experience is needed to understand the type of thread to use and the size of the stitch required to produce the desired results.

Basically the size of the needle and the thickness of the thread used will govern the size of the bullion stitch produced. However, fullness of stitch is also determined by how tightly you pull the stitch when laying it on the fabric. No two students will produce exactly the same results. It is, therefore, necessary to establish your own tension and understand how to adjust your stitches to give the required results.

I strongly recommend that you work a sampler using as many different threads as you have available, keeping careful notes about the size of needles used, the type of thread and the number of wraps worked on each practice stitch. This can save a great deal of time when starting a project while providing at the same time the necessary practice to perfect the bullion stitch.

As previously stated, bullion stitch is easier to work using a single strand of thread. If you are a beginner it will be easier to see what you are doing if you work with a medium weight thread, Kanagawa 1000 being an ideal choice (refer to chapter 1), used in a straw needle size 4 or 5.

The way a thread is spun (ie in a clockwise or anti-clockwise direction) can dictate which way the thread should be wound around the needle when wrapping a bullion stitch. The basic rule is to wrap the thread around the needle in the same direction as the twist of the thread; if the thread appears to unravel as you work, try wrapping in the opposite direction.

TO WORK A BULLION STITCH
Secure the thread with a small back stitch where it will be covered by the stitching. A knot can be used, but be careful not to pierce the knot with the needle when working the bullion stitch.

- Bring the needle up through the fabric at point A.
- Take the needle down at point B, about 5 mm from point A, and back up through point A (but not through the thread).
- Slide the needle forward, but *do not* pull the needle right through the fabric at this time.
- Position the first finger of the left hand under the

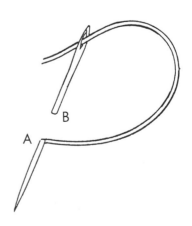

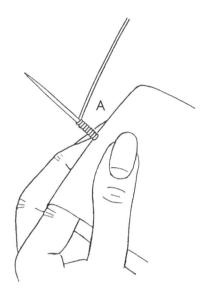

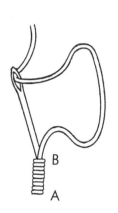

Bullion Stitch

fabric and the needle, and the left thumb on top of the fabric a short distance ahead of point A.

- Place the second finger of the left hand firmly against the eye of the needle, forcing it against the first finger of the left hand, to make the point of the needle stand straight up (this is only possible if you are not using a hoop).

- Pick up the thread in the right hand and wrap the thread around the needle seven or eight times. See page 7 to establish the direction of the wrapping.

- Hold the wraps gently between the thumb and the first finger of the left hand and pull the needle through.

- Tighten the thread until the wraps are even by pulling the thread gently in line with the direction of the stitch back to point B. Keep it parallel with and as close to the surface of the fabric as possible.

- The wraps may be moved gently along the core thread by using the thumb and forefinger of the left hand or the left thumb nail.

- When the stitch has been tightened the wraps should sit snugly against the fabric at point A and point B. Failure to tighten the core thread sufficiently at this point will result in untidy loops at one or both ends or if using a slippery thread the wraps may slacken as the stitch is anchored, resulting in an untidy stitch.

 If the core thread is tightened too much this may result in puckering of the base fabric.

- Once the stitch has been adjusted satisfactorily, anchor the bullion by passing the needle to the back of the work at point B.

The core thread should be completely and evenly covered by the wrap thread. If the wraps are too tightly packed to lie flat, use fewer wraps; if the wraps do not cover the core thread, resulting in a 'strung out' skinny stitch, add more wraps around the needle.

The number of wraps required to give an even result depends on:
 a) Thickness of thread used
 b) The length of stitch required
 c) How tightly the thread is pulled to finish the bullion stitch, which has a direct bearing on the thickness of the finished stitch. The tighter the tension the thinner the bullion.

If the wraps do not tighten evenly it may be possible to loosen the core thread gently and re-tighten the stitch,

depending on the type of thread being used.

Rolling the stitch gently from right to left under the thumb may help to even the wraps, provided the thread is wrapped in a clockwise direction around the needle. Roll in the opposite direction if the bullion is worked with an anti-clockwise wrap.

STRAIGHT AND CURVED BULLION STITCHES

A straight bullion stitch requires just enough wraps to cover the thread smoothly as it spans the gap between points A and B.

To create a curved stitch between points A and B the core thread will be left slightly longer to allow for a curve and therefore more wraps will be needed in order to cover it. For example if seven wraps cover the straight stitch then ten to twelve wraps will be required to cover the curved stitch.

To work a bullion loop stitch the distance between A and B is reduced and the number of wraps is increased.

Success with bullion stitch does depend largely on accurate judgement and consistent tension. Many experienced workers do not need to count the number of wraps used, they work by eye wrapping the needle until it 'looks right'! Working this way takes a great deal of practice and largely depends on how much and how often you work this type of embroidery.

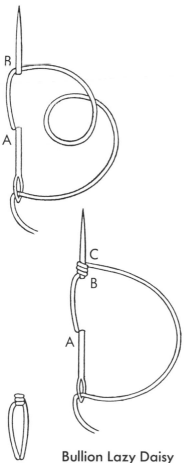

BULLION LAZY DAISY STITCH

This is a variation on the standard lazy daisy stitch. A small bullion stitch takes the place of the usual anchor stitch at the point of the petal. The shape of the petal or leaf will depend on the length of the bullion stitch used.

The secret of this stitch is to keep the thread taut at all times and tighten it firmly before anchoring the bullion.

Bring the needle up at point A, take it down again at point A and out at point B remembering that the bullion part of the stitch will extend beyond this point. Bring the thread under the point of the needle and wind it around the point of the needle two or three times. Lay the thread firmly to the base of the stitch, and hold in place gently by covering with the left thumb as you pull the needle through, keeping the thread close to the fabric and in line with the bullion stitch. Anchor the bullion stitch by returning the needle to the back of the fabric at the very end of the bullion (point C on the diagram).

Bullion Lazy Daisy

COLONIAL KNOT

(also known as the candlewicking knot)

This knot is larger and firmer than a french knot. It is attractive as it sits up well on the fabric. The thread is wound around the needle in a figure eight.

Maintaining a flexible relaxed wrist is the key to easy execution of colonial knots allowing easy change of direction as the thread is picked up on the needle.

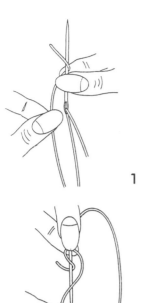

1

- Bring the needle up through the fabric and hold the thread between the thumb and first finger of the *left* hand, leaving a loop approximately 8 cm (3 inches) in length.

- Slide the first finger of the *right* hand under this loop and 'sandwich' the thread between this finger and the needle, which should be pointing away from you, and hook the needle under the thread (figure 1).

2

- Turn the needle anti-clockwise through 180 degrees and hook the needle under the thread again (figure 2).

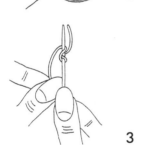

- Return the needle in a clockwise direction to the original position and pass the needle back through the fabric close to but not through the original exit hole (figure 3).

3

Colonial Knot

To produce well shaped, even knots always neaten the thread around the shaft of the needle, while the needle is held in a perpendicular position in the fabric, before completing the last step.

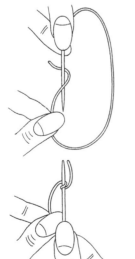

HALF COLONIAL KNOTS

These knots are smaller than a full colonial knot, being similar in size to a french knot but more firmly twisted.
It is the second half of a full colonial knot.

- Bring the needle up through the fabric.
- With the needle pointing towards you, pick up the thread as shown in the diagram.

Half Colonial Knot

- Finish as before.

FLY STITCH

Bring the needle up on the left hand side of the petal, loop the thread from left to right, take the needle down on the right and bring it to the surface at the tip of the petal *over* the looped thread. Pull through and anchor by taking a tiny straight stitch over the thread at the tip of the petal.

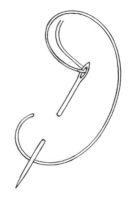

Fly Stitch

FEATHER STITCH

This stitch is useful for defining a shape that will be embroidered with a random selection of flowers, for example the spray illustrated on the cover. It can also be very useful as a background fill of fern type leaves.

- Bring the needle up at A at the top of the line to be followed.
- Take the needle down through the fabric below this point and to the right of the line (point B).
- Slant the needle down slightly and bring it back to the surface on the line with the thread looped under the needle. Pull the needle through (point C).
- Repeat the stitch inserting the needle to the left of the centre line. Continue working down the line, alternating the stitches from side to side.
- This is a 'one-way' stitch, take care that all the stems point in the right direction on a design.

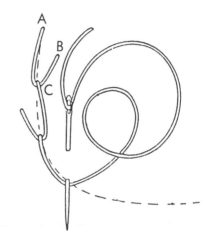

Feather Stitch

PISTOL STITCH

Always use an embroidery hoop or frame for this stitch.
- Bring the needle up at point A.
- Pick up the thread once or twice around the needle.
- Return the needle to the back of the work the required distance from point A, pulling the thread taut around the needle as the needle is passed through the fabric.

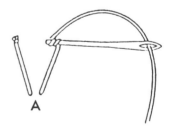

Pistol Stitch

COUCHING

It is easy to work fine stems with a natural curve using couching.

Very short stems can be worked with a single needle, however, for longer stems greater control is maintained by using two needles. The first needle carries a thread

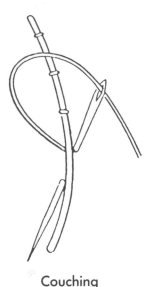

Couching

of suitable thickness for the required stem, usually one to four strands of embroidery thread. The second carries a single matching strand of thread. Always work this stitch in an embroidery frame.

- Using the first needle, come up at one end of the line to be covered and go down at the other. Anchor this needle out of the way.
- Bring the second needle up close to the starting point of the first thread and work tiny invisible straight holding stitches across the main thread, curving the main thread as desired.

SATIN STITCH

Satin stitch is used for some of the larger leaves featured in the Australian wildflower designs.

This stitch should be worked in a frame to prevent puckering of the background fabric. Satin stitch will look smoother and more even if it is worked with a fine thread and needle. Use one or two strands and lay each strand side by side, avoiding any cross-over threads.

It is usually easier to lay the first stitch across the body of the area, thus achieving a good angle for the main stitching area. Build the stitching up on either side of this foundation rather than starting at an odd angle across a corner.

Start by anchoring the thread with tiny running stitches across the area to be covered. Bring the needle through from the back at point A, take it to the back of the work at point B. For the second stitch come up at C and down at D, working as close to the first stitch as is necessary to completely cover the background fabric.

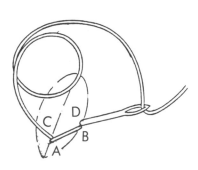

Satin Stitch

LONG AND SHORT STITCH

As with satin stitch, it is necessary to keep the working thread untwisted and evenly spread. This is most easily achieved by running the needle under the thread to tension it and spread it as evenly as possible.

The stitch may be used in two ways. One is to work evenly over the same number of threads every time to give a symmetrical pattern.

The alternative is to work a random pattern, filling in the area.

Work two rows at a time. Half the stitches of each row are worked in one direction, the work is then turned and the spaces filled by working back to the starting point.

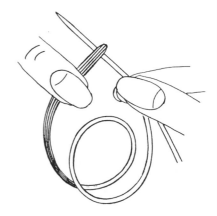

Spreading the Thread

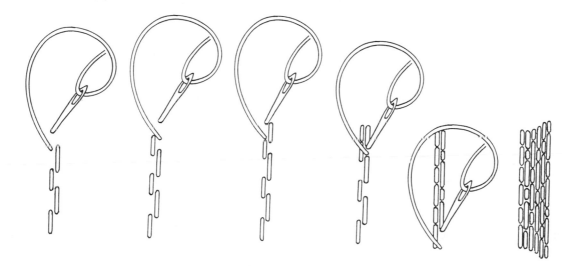

Long and Short Stitch

LADDER STITCH

This is a simple and neat way to close seams left open for turning, and for invisibly joining two sections of work together.

Pick up a few threads of fabric along the seam line on one side then pick up the same distance along the seam line of the other side of the opening. The cross-over thread represents the rung of the ladder, the pick up sections the side supports.

As long as a stong enough thread is used, several stitches can be worked and then tightened really firmly to pull the two sides together securely.

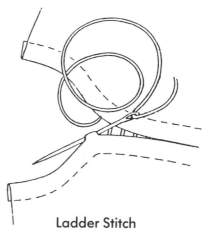

Ladder Stitch

FLOWERS

The construction of flowers is described in this chapter. In the accompanying stitch placement diagrams, bold lines are used to indicate the stitch placement being described, whereas lighter lines and broken lines show previously completed steps.

ROSE BUDS

The easiest of the flowers to work, rose buds are commonly used for decorating baby wear and smocking.

Small Rose Bud

(Illustrated in colour on sampler: 3D)

These rose buds are made up of three straight bullion stitches.

- Using Kanagawa 1000 thread or similar in a pale shade, work two bullion stitches, starting and finishing in the same holes. The original sample was worked with ten wraps over 5 mm (³/₁₆″).
- Using thread a shade darker, work a third bullion *between* the first two stitches, wrapping eight times and starting and finishing in the same holes again.
- Finish the base of the bud with green thread, working a straight stitch coming up at the base of the bud and going down halfway up the centre bullion. Bring the needle back up on the left hand side of the bud, down on the right and out at the base with the thread under the needle to form a 'V' stitch (see diagram).

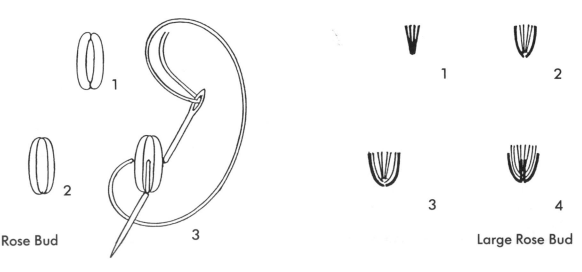

Rose Bud

Large Rose Bud

Large Rose Bud

Illustrated in colour on sampler: 3 A-C.

The colours used in the sampler are Kanagawa 1000 Nos 91, 93 and 94.

- Work a fan-shaped centre in satin stitch, using three or four straight stitches all originating from the same base spot and spreading slightly at the top.
- Using the medium shade, work one eight-wrap bullion stitch on either side of the satin stitch.
- Using light thread, work two ten-wrap bullion stitches from the centre of the base around the outside of the previous two bullions.
- Using green thread, work one eight-wrap bullion up each side of the bud, starting at the centre of the base.
- Work two satin stitches from the base to halfway up the centre of the bud.
- Add a couched stem and leaves as desired (see page 11).

BULLION ROSES

There are many ways of working roses. Once you have mastered the basics of forming a well-shaped flower, your own individual variations will be more satisfying than copying someone else's ideas. Roses may be graded up or down in size by varying the choice of thread.

The good, rounded shape of the rose is easy to achieve, provided you overlap each petal sufficiently and pay careful attention to the stitch positions given in the diagram. However, the high-domed shape of a good rose may require a little more practice, but is not difficult provided you maintain a clear picture in your mind of the direction in which you are working (normally clockwise for right-handed people) and you keep to it.

Study the diagrams carefully and follow the instructions step-by-step. Emphasis has been given to the points where students usually have difficulties.

You will require two or three shades in your chosen thread colour. The colours used on the sampler are Kanagawa 1000 Nos 91, 93 and 94.

Bullion Rose 1

- Using the darkest shade (No 91 Kanagawa 1000), work three straight bullion stitches side by side, using eight wraps for each stitch [Nos 1 to 6 on diagram 1].
- Starting just outside this and using a shade lighter in thread, work one ten-wrap, slightly curved stitch from 7 to 8. Make sure this stitch is the right length, as indicated in the diagram; there is a tendency to underestimate the length required. To start the next stitch bring the needle up halfway along and on the *inside* of the stitch just completed [No 9], take the

Bullion Rose 1

needle down at 10, an equal distance past the end of the first stitch. Continue overlapping the stitches in this way until the circle is completed with stitch 13-14.

● Start the second circle of stitches, using the lightest shade thread, by laying down one ten-wrap bullion *outside* the previous circle [Nos 15-16]. Note this stitch is not overlapped by any stitch from the previous row. Continue working stitches according to the numbers on diagram, noting that the number of wraps used for each stitch is the same, but at least one extra stitch is used in each succeeding circle.

● *Always* come up on the *inside* of the petal just worked and *always* work in the same direction — I teach right-handed people to work in a clockwise direction and left-handed students to go anti-clockwise. Working this way means that each time the needle passes under the back of the work it is passed across the centre of the flower and this is an important factor which helps to lift the centre of the rose. Likewise bringing the needle up on the inside of the previous bullion helps to keep the stitches compact and tight.

● Note that the last but one stitch in each circle should almost meet the starting point of the first stitch of the same row in order to allow the correct overlap of the final stitch in the circle.

Bullion Rose 2

Illustrated in colour on sampler: 1 A-D.

This is a larger version of the previous rose and is worked in exactly the same way except that the centre three bullion stitches have been worked over with satin stitch, resulting in a slightly larger centre which is surrounded with six eight-wrap bullion stitches.

The second circle consists of eight nine-wrap, stitches.

A third circle has been added to produce a larger rose consisting of ten ten-wrap stitches

Bullion Rose 3

Illustrated in colour on sampler: 2 A-D.

This rose is a one-sided rose and illustrates how shape can be varied by altering stitch placement. The same three shades of Kanagawa 1000 were used as for the previous rose.

● With the deepest shade, work three eight-wrap

bullion stitches side by side.

- Using the second shade, work three eight-wrap bullion stitches in a triangle around the centre three. Note these stitches do not overlap each other in any way. The stitches meet end-to-end and must therefore be worked in the order shown in the diagram.

- Using the palest thread, work four overlapping eight-wrap bullion stitches, commencing halfway along stitch 3-4 and working in a clockwise direction around the base and halfway up the other side.

- Work the final row using eight eight-wrap stitches, commencing close to the top of the rose just short of point 4. Add a couched stem and leaves as desired (see page 11). Note that the direction in which this rose points is dictated by the angle at which the first three bullion stitches are worked.

OTHER FLOWERS

*Tulip Shaped Flower*_____

Illustrated in colour on sampler: 4 A-C.
The colours used in the sampler are Kanagawa 1000 Nos 4 and 10.

- Using the darkest shade, work two eight-wrap bullions close together.

- Using the lighter colour, work an eight-wrap bullion on either side of the first two.

- Work a second ten-wrap bullion on either side of the last two, starting each one at the centre of the base of the flower and ending each level with the top of the other stitches. These stitches will lay on top of the bottom section of the stitches already worked.

- Work one more ten-wrap bullion on each side of the flower, starting each one at the centre point at the base of the flower. These stitches will lay under the bottom section of the previous two stitches, thus supporting the shape of the flower.

- Using green thread, work a six-wrap bullion stitch around the base of the flower, followed by a second eight-wrap stitch directly over the top of the smaller green stitch and curving in around the base of the petals to give further support.

- Add a couched stem and leaves as desired (see page 11).

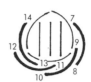

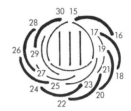

Bullion Rose 3

Tulip Shaped Flower

Tiny Petal Flower

Tiny Petal Flowers

Illustrated in colour on sampler: 4D.

These flowers can be worked as tiny roses or any other type of flower. The flowers on the sampler are worked in two shades of blue, with a yellow centre. For a rose use three shades of the same colour.

- Work a colonial knot for the centre using three strands of stranded cotton.
- Work three six-wrap overlapping bullion stitches in a tight circle around the knot.
- Work three eight-wrap stitches around the outside. These stitches do not overlap each other but meet end-to-end around the circle and will shape the flower better if they are centred over the joins in the previous row.

Daisies

Illustrated in colour on the sampler: 5 A & B.

These flowers can be worked in any colour and as only one shade is required, the choice of suitable threads is wider.

It is essential to have a focal point for the centre of the flower when working petals that radiate out from the centre, otherwise petals may be laid down off-line, producing an oddly shaped flower.

- Mark a tiny spot for the flower centre and imagine this as a clock face.
- Using Kanagawa 1000, work four six-wrap straight bullion stitches at twelve, six, three and nine o'clock, starting each one close to the centre dot.
- Position two more bullion stitches between each of the stitches already worked.
- Work a colonial knot in yellow for the centre and add a couched stem and bullion leaves as desired (see page 11).

To make a larger daisy, start with a larger centre circle and work petals in a corresponding size in the same order, adding more than two petals in each quarter section if required. Work a cluster of colonial knots to fill the centre.

I prefer to add the centres to this type of flower last as it looks more natural. The centre knots should cover the base of the petal stitches, giving the appearance that the petals come from behind the centre, which they do in real life.

Daisy

Tiny Hanging Flowers

Illustrated in colour on the sampler: 5C.

These make pretty flowers hanging from a stem and can be worked either in two shaded colours or one single colour.

- Work a single eight-wrap bullion stitch.
- Work a twenty-wrap loop bullion stitch around the single stitch as follows. Start and finish at the top of the stitch, picking up a very small amount of fabric on the needle. Wrap the needle twenty times and tighten the stitch, forming a loop. Use a single couching stitch over the middle of the loop, to hold it in place around the straight bullion stitch.
- Using a single thread of green, work a fly stitch at the top of each flower and couch in a curved stem.

Tiny Hanging Flowers

Raised Bullion Buds

Illustrated in colour on the sampler: 5D.

These buds may be worked hanging down like bells or straight up as buds.

- The bud or bell is based on three overlapping bullion loop stitches (see diagram for stitch positions). Work each loop with twenty to twenty-five wraps, tightening the stitch until the loop stands firmly on the fabric.
- Two small six-wrap bullion stitches cover the base of the petal stitches.

Raised Bullion Bud

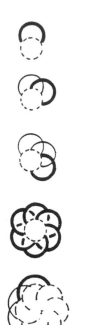

Camellia, Peony or Open Rose

Camellia, Peony or Open Rose

Illustrated in colour on the sampler: 6 A-C.

This flower is very effective and not difficult to work, provided a low resistance thread is used. The original sample is worked in Silk Stitch No 140.

It is easy to make this flower larger by using heavier thread and/or more wraps and rows.

- Start the flower by marking the centre — approximately 2 mm ($^{1}/_{16}$ inch) in diameter for the sample shown.
- Work six overlapping twenty-wrap bullion loop stitches in a circle around the centre mark.
- Start a second row outside the one already completed and work eight twenty-five-wrap overlapping stitches to complete this circle.
- A third circle is added using eleven thirty-wrap loop stitches.
- Fill the centre with colonial knots worked in machine embroidery thread (see page 10).

Note that each row starts under the loops of the previous row so that the bases of the loop stitches are hidden. Also the number of petal loops in each row is not critical to the look of the flower, provided the petals overlap sufficiently and the number of wraps is increased with each row worked.

Blossom

Work as for the start of the camellia, working one row of looped bullion stitch only (figures 1 to 4). Work colonial knots in brown or yellow for the centres.

Tiny Forget-Me-Nots

Illustrated in colour on sampler: 6D.

These can be used to fill in around *larger* flowers or massed together to form delicate little sprays.

- For each flower, work a bullion loop stitch in Kanagawa Silk Stitch thread with twenty to thirty wraps, picking up just two threads of the fabric between points A and B.
- Tighten the stitch firmly into a circle and pass the needle to the back of the work through point A instead of point B.

Tiny Forget-me-nots

- Use a single couching stitch directly opposite this point to anchor the bullion into a circle.
- Fill the centre with a single colonial knot in yellow or cream.

Lavender

The stems are straight and upright and should be couched in first. Work the lavender heads using two strands of Soie Gobelins, one green (No 1813) and one mauve (No 3333), in the needle at once. Starting with a centre bullion stitch at the top of the stem, work six or eight more stitches, tightly packed and alternating down each side of the stem.

Lavender

Leaves

Illustrated in colour on sampler: 2D, 3C, 4C, 5B and 6C

Leaves may be worked in a variety of shapes and sizes, as will be seen from the samples in the photographs. Stitches can be laid side by side to form a solid leaf (2D) or shaped into a curve to form a hollow leaf shape (3C and 6C). Single stitches can be laid straight (5B) or extra wraps added and the bullion couched into a curve (4C).

Bullion Stems and Branches

Work as many wraps as you can handle (I use forty to fifty at a time), remembering that stems are never very smooth so some unevenness in the wrapping will not matter. This also applies to joins if you wish to work fewer wraps and join several stitches together. Make sure you overlap the start and finish of each stem so that there is no actual break in the line.

If you do use a large number of wraps it will be necessary to slide the wraps off the needle as you fill its length.

AUSTRALIAN WILDFLOWERS

It is easier to embroider flowers if you have a clear picture of the flower in your mind. You may find it helpful to refer to accurate pictures of the flowers as you follow the instructions. These may be found in gardening or pictorial books, cards, calendars, etc.

If a specific variety of flower is to be depicted, care must be taken to choose a colour as true as possible to the flower variety. The shape and number of petals worked is also important, as is the size in relation to any other flowers used in the same design.

Many flowers have an uneven number of petals, generally five, rather than an even number such as four or six. Beginners will find it easier to arrange an even number of petals in a circle, but five are not difficult with practice.

To arrange five petals evenly around the flower centre the following image may help. Imagine the flower as a clock face and position the petals as shown in the diagram.

Working the petals so that they radiate evenly from the centre of the flower can be a problem. I find the following method helps to prevent petals from slipping sideways and distorting the shape of the flower.

- Work the first petal at twelve o'clock then bring the needle back through the fabric at the base of the next petal.

- Now *turn the work* so that the petal to be worked is in the twelve o'clock position. Complete this petal, position the needle at the base of the next petal before turning the work again.

Working each petal in the same position makes judging the length easier and ensures even radiation from the centre.

Many of these flowers depend on working a long bullion stitch and couching it into the desired shape. If the couching stitch is worked with the same thread as the bullion and the stitch is worked so that it follows the line of the wraps it will be barely noticeable.

The flowers are listed according to the degree of difficulty, easiest first.

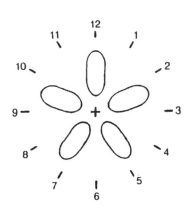

Petal Placement

Wattle

Stitches used:
 colonial knots — flowers
 bullion lazy daisy — leaves
 couching — stems

Threads: All stranded cotton.
 DMC No 726 (yellow) — flowers
 DMC No 3053 (green) — leaves
 DMC No 840 (brown) — stems

- Work a network of single-strand couched stems, to give a main outline.

Wattle

- Using two or three strands, work clusters of colonial knots down each stem.
- Work tiny bullion lazy-daisy stitch leaves between the clusters of flowers.

*Bottle Brush*_____

Stitches used:
 bullion stitch — branches
 colonial knot — nuts and flowers
 straight stitch — leaves

Threads:
 Kanagawa 1000, brown (No 54) for branches
 DMC stranded cotton:
 No 840 (brown) — nuts
 No 838 (dark brown) — nuts
 No 3347 (green) — flower clusters and leaves
 No 666 (red) — flowers

Bottle Brush

- Work the branches in bullion stitch, couching into place and joining where necessary (joins can be hidden under clusters of nuts).
- Using four strands of the brown cotton and a size 3 or 4 straw needle, work colonial knots along the stem to form clusters of tiny nuts, allowing room towards the tip of the branches for the flower clusters and leaves.
- Using a single strand of dark brown and a size 8 or 9 straw needle, work a second colonial knot in the centre of each knot already worked.
- Using four strands of green and the large needle, work clusters of colonial knots in green towards the tip of the branches.
- Using a single strand of red cotton double in the fine needle, work tiny tufts or loops in the centre of each knot to represent the flowers just breaking into bloom.

To work tufts, take the needle down through the centre of a knot, backstitch firmly in place, then bring the needle to the front of the work through the same knot and cut the thread. Leave the tufts longer than required, then trim when all have been completed.

To work loops, bring the needle up from the back of the work through the centre of a knot and return it to the back through the same knot, leaving a loop just visible in the centre of the knot. Backstitch firmly before repeating in the next knot.

Start with tufts at the base of the flowerhead, graduating to tiny loops towards the tip, depicting the gradual development of the flowerhead.

- Add straight stitch leaves, using four strands of cotton in the needle.

*Blue Tinsel Lily*_____

Blue Tinsel Lily

Stitches used:
 bullion stitch — flowers and leaves
 couching — stems
Threads:
 Kanagawa 1000 No 117 — flowers
 Kanagawa 1000 No 160 — leaves
 Kanagawa Silk Stitch No 17 — flower centres
 DMC stranded cotton No 840 — stems

- Mark a small dot for the centre of each flower.
- Work six ten-wrap bullion stitches, evenly spaced around the centre, working the first two at six and twelve o'clock. The other petals will be placed at two, four, eight and ten o'clock.
- Using Silk Stitch in yellow, work three fifteen-wrap, looped bullion stitches for the centre of each flower.
- Using three strands of DMC cotton for each stem, couch in place with a single strand.
- Work eight-wrap bullion stitches for leaves up the stems.

Blue Bell

Stitches used:
 bullion — flowers and leaves
 couching — stems

Threads:
 Kanagawa 1000 No 104 — flowers
 Kanagawa 1000 No 160 — leaves
 Kanagawa Silk Stitch white — flower centres

The blue bell has five petal flowers — see page 22 for hints on positioning petals

- Mark a small centre spot for each flower.

- Work each petal as follows: one eight-wrap bullion for the centre. Work a second bullion using twelve wraps, starting the stitch at the same base point and finishing it just above the first stitch.

- Work a third bullion, using sixteen wraps around the outside of these two stitches. Complete five petals for each flower.

- Work a white centre bullion in Silk Stitch, using fourteen to sixteen wraps, starting in the centre and finishing between two petals.

- Use a single thread of Kanagawa 1000 couched into a slight curve for each stem.

- Leaves are worked in the same Kanagawa 1000, using fifteen to twenty wraps couched into curving shapes.

- Buds can be worked using a single petal formation of three bullion stitches.

Blue Bell

Pink Boronia

Flannel Flower

Pink Boronia

Stitches used:
 bullion stitch — flowers and leaves
 colonial knot — centres of flowers

Threads:
 Kanagawa 1000 No 140 — flowers
 Kanagawa Silk Stitch No 161 — leaves
 Kanagawa Silk Stitch No 93 — flower outline
 DMC stranded cotton No 726 — flower centres
 DMC stranded cotton No 772 — flower centres

Pink boronia has only four petals, making it easy to position the petals at twelve, three, six and nine o'clock.

- Start each petal as described for the blue bell, using six, nine and twelve wraps.
- Work a fourth bullion stitch, using twelve wraps, along the other side of the petal.
- Each petal is outlined with a fly stitch in darker pink, starting and finishing at the widest point of each petal.
- The flower centres consist of a colonial knot using two strands of pale green cotton, surrounded by tiny yellow half colonial knots using a single strand of thread.
- Leaves are each formed by three bullions in Silk Stitch, worked exactly as described for the first three bullions of the petals.

Flannel Flower

Stitches used:
 Bullion, colonial knots and back stitch

Threads:
 Kanagawa 1000 or Silk Stitch No 16
 DMC stranded cotton No 504

Flannel flowers have any number of petals from seven to thirteen and are therefore easier to work than more symmetrical flowers.

- Draw a small circle for the centre.
- Start each petal as detailed for the blue bell, working ten, fifteen and twenty wraps on the stitches.
- Work a fourth stitch, using twenty-five wraps, around the outside of the first three.
- Tip each petal with green by working a back stitch over the tip of the fourth bullion using four strands of cotton. Take care to spread the cotton so that the stitch lays smoothly.

- Fill the centre with colonial knots worked with two strands of green cotton.

Kangaroo Paw

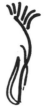

Kangaroo Paw

Stitches used:
 bullion stitch — flowers, stems and leaves
 back stitch — flowers
Threads:
 Kanagawa 1000 No 4 (red)
 Kanagawa 1000 and Silk Stitch No 161 (green)
 DMC stranded cotton No 817 (red)

- Using red Kanagawa 1000, work long stems, couching them into the curved shape as shown in the pattern. These stem sections may be joined and the joins hidden under the leaf stitches.

- Using green, work short six-wrap bullions at the tip of the stem, graduating to twelve to fifteen-wrap bullions at the back of the flower head. Couch the longer stitches into a curve as necessary.

- Using three strands of stranded cotton, back stitch over the base of each green bullion stitch where it touches the stem of the flower.

- Work long spiky leaves in Silk Stitch, criss-crossing them over the red stems and couching them into curves.

Sturt Pea

Stitches used:
 bullion stitch — flowers, stems and leaves
 satin stitch — flowers
Threads:
 Kanagawa 1000 No 5 — flowers
 Kanagawa 1000 No 165 — leaves and stems
 DMC stranded cotton, black

To work a flower that has the appearance of curving round, rather than looking flat, the centre petals should be worked lower than the two outside sections. All petals are worked outwards from the centre.

- The centre top petal is symmetrical and is worked with a centre bullion of six wraps with a ten-wrap bullion on each side, both finishing at the same point just above the first stitch. One fourteen-wrap bullion on each side completes the petal. Couch the tops of the last two stitches to meet each other to form a slender point to the petal.

1

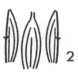

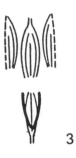

Sturt Pea

- Side top petals, worked a little higher than the centre petal, consist of three bullion stitches of six, ten and fourteen wraps, positioned in the same way as the blue bell petals (page 25), with the fourteen-wrap bullion next to the centre petal. A single strand of thread is couched down the outside edge of these petals to smooth the outline.

- Leave a small gap between the top and bottom petals and work the centre bottom petal next. Work one centre ten-wrap bullion with one sixteen-wrap stitch on either side. Couch the outer stitches to meet below the first bullion. Work two more short wing petals, from the outside towards the bottom of the first bullion, using ten wraps. These stitches cross over the outside bullion stitches towards the centre of the petal.

- The outside bottom petals are worked in the same way as the top outside petals, using eight, twelve and sixteen wraps. Remember they should finish a little higher than the centre petal.

- Work small wing petals, using ten wraps, from between the start of the second and third bullion to the tip of the first bullion and just outside the edge of the petal.

- Work horizontal satin stitches, using three strands of black cotton, to fill the gap between each petal. Satin stitch vertically over these stitches to form a raised centre between each set of petals.

- Work stems, in couched bullion and leaves, as shown in the pattern, using eight-wrap bullions.

Grevillea

Stitches used:
 bullion stitch — flowers, leaves and stems
 pistol stitch — flowers

Threads:
 Kanagawa 1000 No 169 — flowers
 Kanagawa 1000 No 114 — leaves
 Kanagawa 1000 No 54 — stems

Grevillea

- Work woody stems using brown in bullion stitch, joining where necessary and couching in place.

Each flower consists of six to eight bullions fanning out from a common base point, some couched firmly in place while others are left to stand away from the fabric.

- Using pink, work four to six twenty-five- to thirty-wrap bullions, couching them into a tight curve at the top. Add two to four extra bullions, allowing them to stand away from the fabric.

- Using the same thread, work a single pistol stitch from the top of each curved stitch that is firmly anchored to the fabric. Using very fine machine embroidery thread in yellow, work a colonial knot in the centre of the pistol stitch knot.

- Work short, spiky leaves along the length of the stem, using eight- to ten-wrap bullions and criss-crossing them over the stem.

Gum Blossom and Nuts

Gum blossom may be worked in any shade from creamy white to deep pink and bright red.

Stitches used:
 pistol stitch — gum blossom
 bullion stitch — branches, leaves and gum nuts

Threads:
 DMC stranded cotton Nos 712 and 726 (cream) — blossom.
 DMC stranded cotton No 3021 — nuts
 Kanagawa 1000 No 54 — stems and nuts
 Kanagawa 1000 No 114 — leaves
 Machine embroidery thread — golden yellow

- Work the branches using as many wraps for each stitch as you can handle. Joins in branches can be disguised by adding a side branch or leaf over the join.

- Mark the centre of each flower with a small circle.

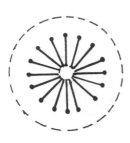

Gum Blossom

- Using a single strand of stranded cotton, work pistol stitch radiating in a circle from the outer edge of the marked centre.

To get an even distribution of stitches, work step-by-step as follows.

The flower is worked in three separate rows. The stitches in row one are equivalent in length to two-thirds of the distance from the outer edge of the centre of the flower to the extreme outside edge of the finished flower.

- First work four stitches to divide the circle into quarters then add three or four stitches in each section.

- For the second row, work a light scattering of longer stitches, taking them to the extreme outside edge.

- For the third row, work a light scattering of shorter stitches from the outer edge of the centre to finish short of the knots of the first row worked.

It is better to underestimate the number of stitches required in each row rather than overwork it. A few extra stitches can be added to complete the overall appearance but it is difficult to unpick if the first row is worked too heavily.

- To finish the flower, use fine machine embroidery thread and work a tiny half colonial knot over the end of most of the pistol stitches. To work these stitches, bring the needle up just outside the knot of the pistol stitch and return it through the centre of the knot.

- Satin stitch the centre with fine green thread and work a long curved bullion stitch for the pistol.

Gum Nuts

Stitches used:
 Bullion and satin stitch

Threads:
 Kanagawa 1000 No 52 for bullion stitch
 DMC stranded cotton No 3021 for satin stitch

- Draw the shape of the nut lightly on the fabric.
- Fill in the top section with bullion stitches, along the length of the nut, of approximately eight wraps each. A more symmetrical shape will result if the first bullion is worked down the centre of the area.
- Fill in the bottom shaded area with satin stitch.
- Work a twenty- to twenty-five-wrap bullion loop around the top of the nut and couch it carefully into place.
- Work an eight-wrap bullion stitch on either side of the satin stitch, couching in place as necessary.

Gum Nut

Gum Leaves

Stitches used:
 Bullion stitch or satin stitch

Threads:
 Kanagawa 1000 No 114 for bullion stitch
 DMC stranded cotton No 522 for satin stitch
 DMC stranded cotton Nos 524 or 301 for couching

- To work bullion leaves, as shown on the clock design, outline each leaf shape with long bullion stitches and couch into place.
- To work satin stitch leaves, as shown in the picture design, satin stitch each leaf, then couch a single thread of cotton around the outer edge. Use the same thread to couch a vein down the centre of the leaf.

Heath

Stitches used:
 bullion stitch — flowers and leaves
 satin stitch — flowers
 couching — stems

Threads:
 Kanagawa 1000 No 7 — flowers
 Kanagawa 1000 Nos 157 and 160 — leaves
 Kanagawa Silk Stitch Nos 140 and 170 — flowers
 DMC stranded cotton No 407 — stems

- Couch the stems in place.

Heath

- Work single six-wrap bullions in pink at the top of each stem.
- Work single eight-wrap bullions in pink underneath.
- Work double eight-wrap bullions in pink below these, leaving room for leaves between each row of flowers.
- Each fully opened bell is worked as follows.
 — Work three eight-wrap bullions side by side.
 — Satin stitch a tiny circle in deep pink across the base of each set of three bullion stitches.
 — Using pale pink Silk Stitch, work five tiny four-wrap bullions in a circle to outline the satin stitch.
 — Cluster the bells around the lower half of the stems.
- Add short, spiky leaves worked in between each row of flowers, using eight to ten wraps for each leaf. Use the lighter green at the top of the stem and the darker shade towards the bottom.

*Banksia*_____

This is one of the more difficult flowers to work due to the shape of the cone and denseness of the stitching.

A hoop is recommended for working bullion lazy daisy.

Stitches used:
 Bullion lazy daisy, bullion and satin stitch
Threads:
 Kanagawa 1000 No 16 — cone
 Kanagawa 1000 No 52 — branch
 Kanagawa Silk Stitch No 19 — base of flower cone
 DMC stranded cotton No 502 — leaves

- Trace the outline of the cone given here and transfer to the fabric. Mark a vertical line down the centre of the cone to help line up the stitching symmetrically.
- Commence stitching at the centre top of the cone (point *) and work one bullion lazy daisy stitch. Keep the lower half of the stitch very small, picking up three or four threads only on the needle and using four wraps around the needle. Work one more stitch on each side of the first stitch.

Note that the bullion part of each stitch should be half the length of the whole stitch.

- Move down so that when the next row of stitches is completed, the bullion part of each stitch will fill the gap beside each lazy daisy section of the previous row.

 Work two straight bullion lazy daisy stitches in the gaps between the first three stitches. Work two more stitches, one on each outer edge, sloping them in towards the top centre of the cone.

- Move down and work the stitches of each successive row between the stitches of the previous row. Overlap stitches as before, increasing each row and shaping the outside stitches in towards the centre line until the full width of the cone is established. Continue working straight rows, filling in the area.

- To finish the flower, cover the base of the cone with bullion stitch, using twenty to thirty wraps and allowing the stitches to vary in length and placement to give a slightly dishevelled appearance. A second row is worked under the first row, overlapping the stitches on the first row and graduating down to the base of the flower.

- Stems are worked with long bullion stitch couched into place.

- Leaves are worked in satin stitch, using two strands of stranded silk or cotton. The outline of each leaf is back stitched with a single strand of the same thread. The centre vein is a single strand of thread, slightly paler than the leaf colour, couched in place.

Banksia

Waratah

Stitches used:
 bullion lazy daisy — cone
 bullion stitch — base around cone and stems
 satin stitch — leaves

Threads:
 Kanagawa 1000 No 4 — flowers
 Kanagawa 1000 No 52 — stem
 DMC stranded cotton No 367 for satin stitch.

The cone of the waratah is worked in exactly the same way as the cone of the banksia (see page 32), varying only in the shape.

- Use the outline given to establish the shape of the cone and mark a line down the centre of the cone (this should help to keep the stitching symmetrical). Work according to the method given on page 32. Starting with five stitches in the first row, work one central vertical stitch and slope two on either side in towards it at the top. Fill the cone, increasing and decreasing as required. Note that all the outside stitches in the top half of the cone are sloped in towards the top centre of the cone to give a rounded appearance. You may find it easier to maintain a more symmetrical look to the cone if each row is worked from the centre outwards.

- The petals around the base of the cone are worked in the same way as the petals for the top half of the sturt pea, or the flannel flower, shaping them with three or four bullions worked with five, ten, fifteen and twenty wraps.

- The stem, worked as a long bullion couched into place, and satin stitch leaves complete the design.

Waratah

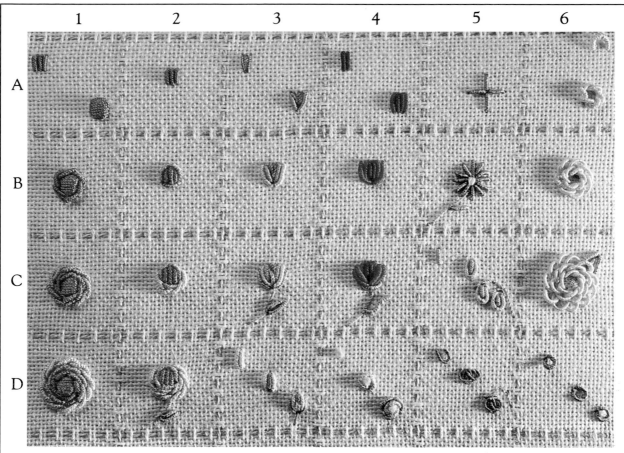

SAMPLER SHOWING CONSTRUCTION OF FLOWERS.

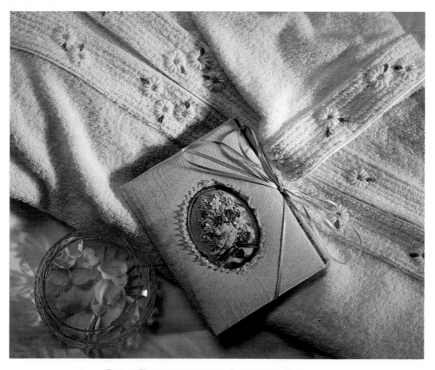

BOLD DESIGNS GIVE A STRIKING EFFECT.

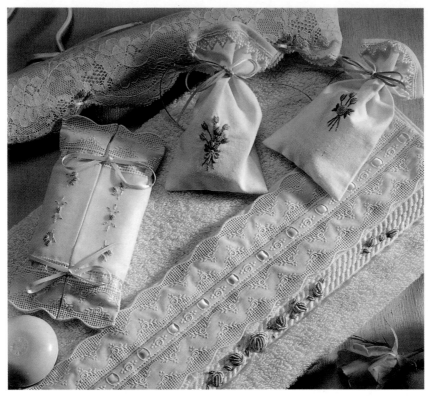

PRACTICAL IDEAS FOR GIFT GIVING.

WALL PICTURE AND CHATELAINE FOR SCISSORS WITH WILDFLOWER DESIGNS.

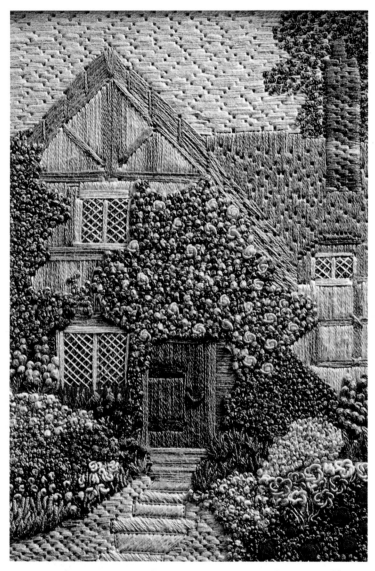

COTTAGE GARDEN, USING BULLION STITCH AND COLONIAL KNOTS.

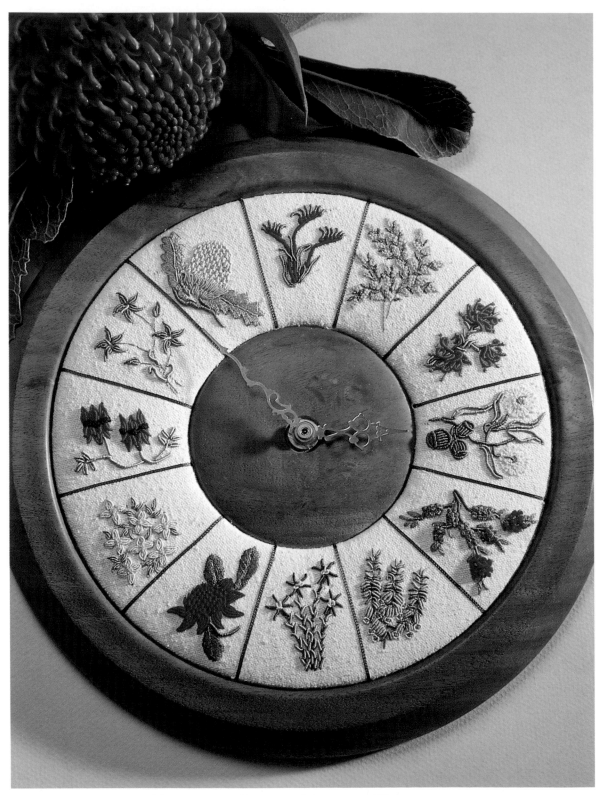

HAND TURNED CLOCK OF AUSTRALIAN WILDFLOWERS.

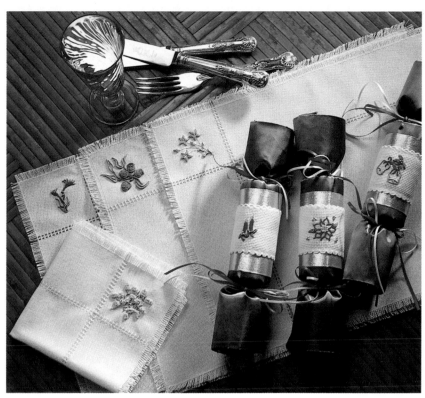

EASY-TO-MAKE TABLE MATS AND CHRISTMAS CRACKERS.

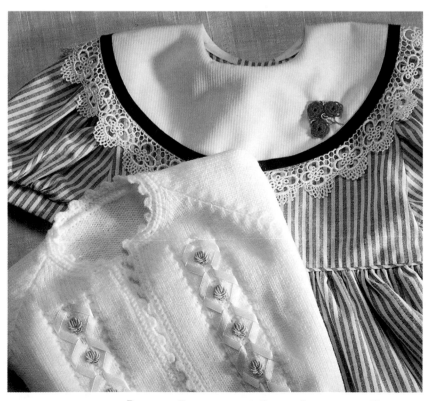

BULLION EMBROIDERED BABY'S JACKET AND DRESS.

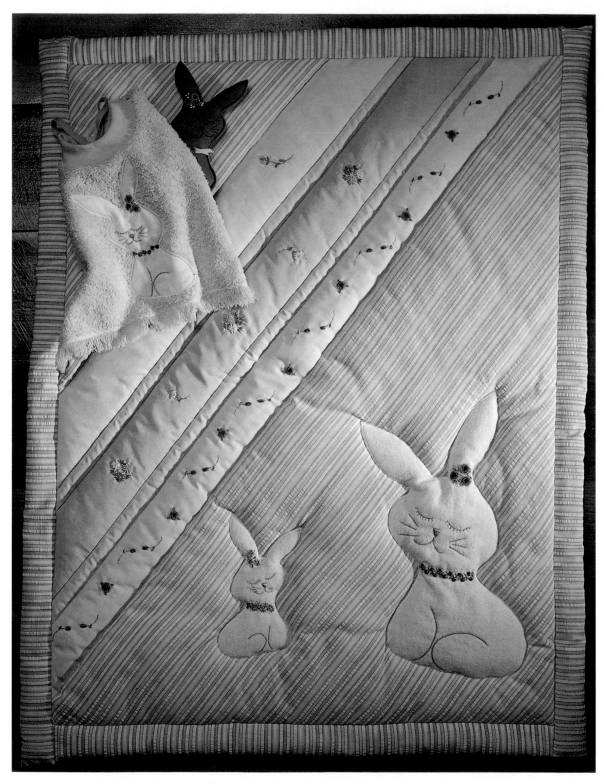

RABBIT DESIGN FOR BABY'S THINGS.

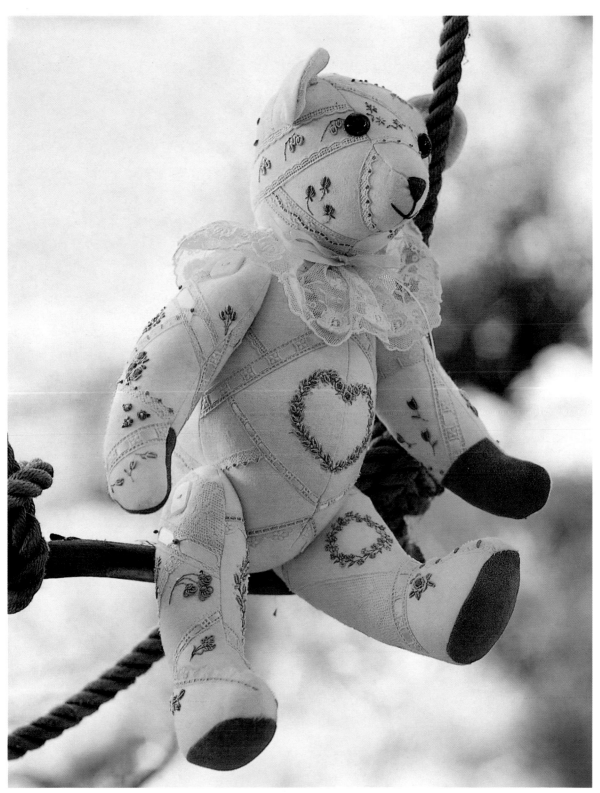

EMBROIDERED HEIRLOOM TEDDY BEAR.

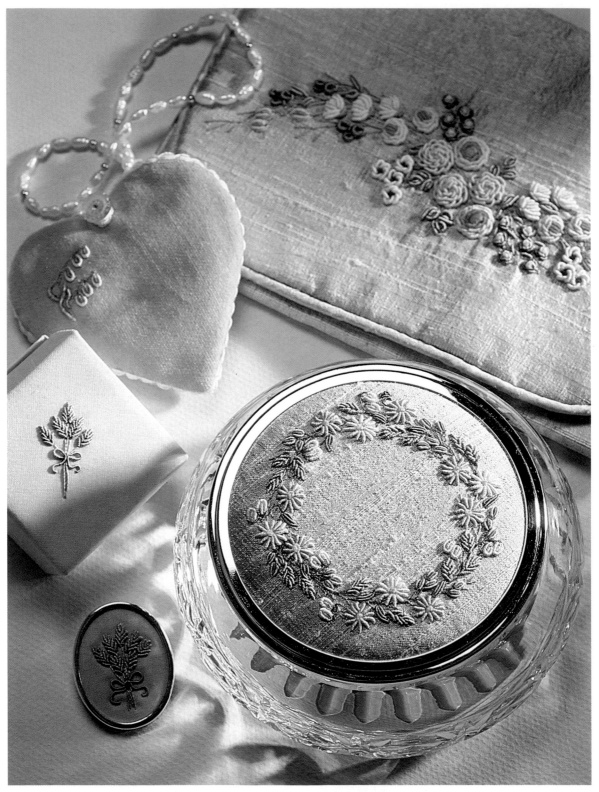

SILK BAG AND OTHER GIFT IDEAS.

PROJECTS AND DESIGNS

BAGS

There are numerous and varied ways of making bags and purses and in many cases one way is as good as another. I was, however, intrigued by the neatness and simplicity of a method devised by Jean Wilson of the ACT Embroiderers' Guild. I am indebted to Jean for allowing me to print her method here and also for making up the sample bag shown on the colour pages.

This construction method can be used for any size envelope bag, glasses case or tissue pack holder. It is neat because it is seamed together in a single process and has no stitching showing on the inside or outside.

TO CONSTRUCT AN ENVELOPE STYLE BAG OF ANY SIZE

- Prepare a paper pattern for the size of the bag required. Fold the pattern to give the desired finished result and mark points A, B, C, D, E, F and G, as shown for the bag pattern on page 37. Note that it is much easier to work with rounded corners on the front flap.

- Mark the cutting line onto the outer fabric.

- Attach the interlining and work any decoration that is required.

- Check the design position carefully and cut the outer fabric to the exact size required. Cut a lining piece to match.

- Prepare the piping. Join bias strips as required, fold the strip over the piping cord and tack or machine to keep the cord in place (Note: always use a zipper foot when sewing piping). Trim the raw edges of the strip to equal the seam allowance of the bag.

- On the right side of the outer bag, mark points A, B, C, D, E, F and G with pins.

- Starting from point A, pin the piping through B, C, D to E, easing it around the curves and keeping all the raw edges level.

- Unpick the ends of the piping and very carefully cut the cord to the exact length. Fold the excess bias covering at right angles out to the raw edges (fold back at correct length, then fold at 45 degrees towards the raw edges).

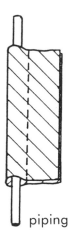

piping

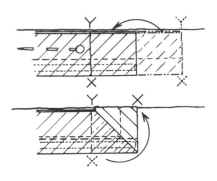

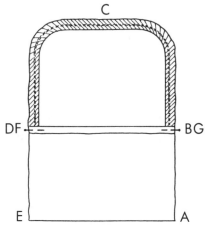

finished ends
of piping

- Tack or machine A to E slightly closer to the cord than the first row of stitching.
- At the lower end, trim away 1 cm (⅜″) from the interlining and press the remaining 1 cm fabric seam allowance to the wrong side, over the edge of the interlining.
- Match points F and G to D and B respectively and pin with the heads of the pins clearly visible outside the edge of the bag.
- Take the lining and press the seam allowance along the straight edge F-G to the wrong side.
- Match this fold, *wrong sides together* to points BG and DF on the main bag, replacing the holding pins through all thicknesses.
- Fold the curved end of the lining up to meet the curved end of the cover, but make the lining fractionally shorter than the cover at AE. Pin the lower folds AE and AE and smooth the lining fabric towards point C; any excess fabric at point C will be trimmed off later. Pin all layers together, placing pins inside the shape.
- Turn the piece over and machine, following the previous stitching line from A through B, C, D to E.
- Remove all pins and turn inside out. You now have a good looking flap but two outside pockets.
- Turn the outside pocket right way out over the lining pocket.
- Check the finish of the bag before turning it inside out again to make any minor adjustments and trimming the turnings, in layers, so that they do not form a bulky edge.
- Turn the bag right side out, pin the upper edges of the pocket together and slip stitch in place.
- Press lightly if necessary.

lining

Bag

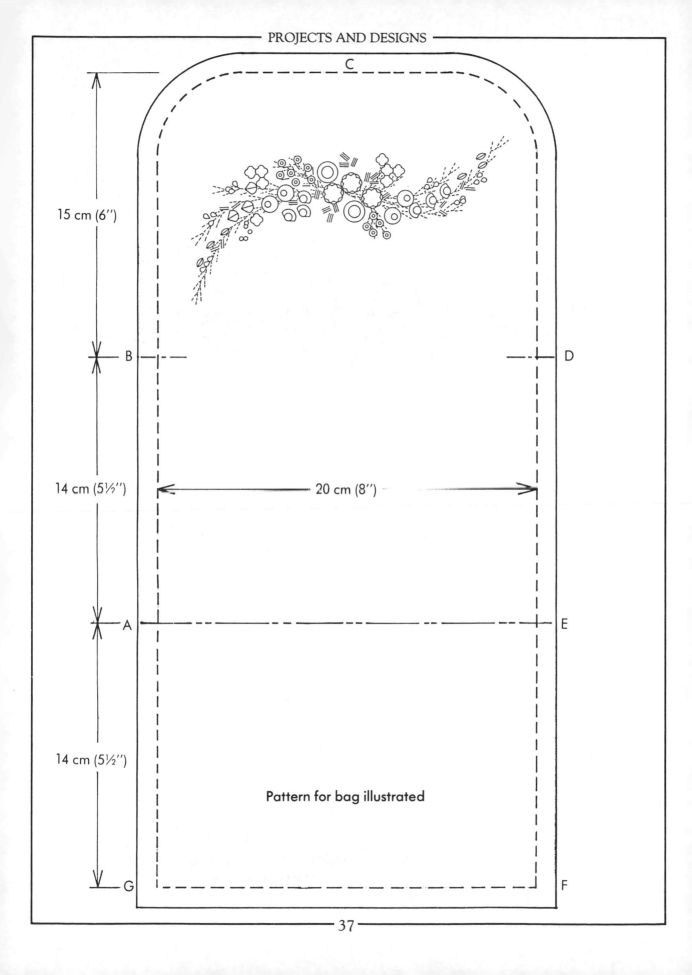

15 cm (6")

14 cm (5½")

20 cm (8")

14 cm (5½")

B

D

A

E

C

G

F

Pattern for bag illustrated

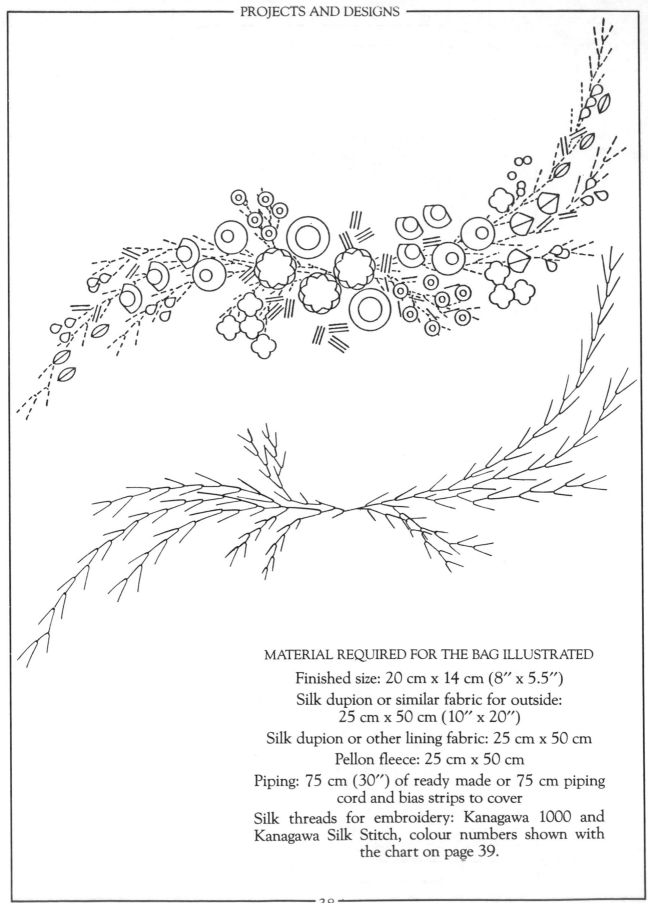

MATERIAL REQUIRED FOR THE BAG ILLUSTRATED

Finished size: 20 cm x 14 cm (8″ x 5.5″)

Silk dupion or similar fabric for outside:
25 cm x 50 cm (10″ x 20″)

Silk dupion or other lining fabric: 25 cm x 50 cm

Pellon fleece: 25 cm x 50 cm

Piping: 75 cm (30″) of ready made or 75 cm piping
cord and bias strips to cover

Silk threads for embroidery: Kanagawa 1000 and
Kanagawa Silk Stitch, colour numbers shown with
the chart on page 39.

METHOD

- Back the outer bag fabric with pellon fleece, tacking the two layers together smoothly.
- Photocopy or trace the main design lines from the pattern on page 38. Transfer to the bag as detailed on page 5.
- Work the main design lines in feather stitch, as shown in the diagram, using a single strand of Kanagawa 1000 No 114.
- Place a copy of the design over the stitching and pinpoint the centres of the five largest flowers and any others you think necessary. Once the large flowers are worked you may feel confident enough to build the design from that point, translating it in your own way. All flowers used in this design are worked from the instructions given on pages 14-21.

The following is a key to the design used on the bag, which is illustrated on the front cover. The design is worked in Kanagawa 1000 and the colour numbers quoted are for that range of threads.

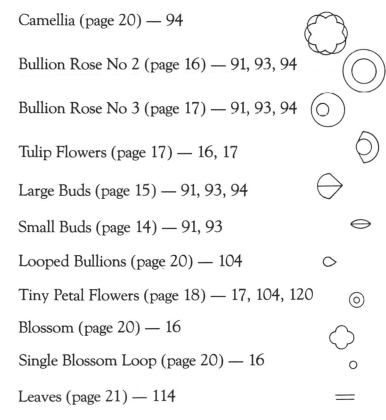

Camellia (page 20) — 94

Bullion Rose No 2 (page 16) — 91, 93, 94

Bullion Rose No 3 (page 17) — 91, 93, 94

Tulip Flowers (page 17) — 16, 17

Large Buds (page 15) — 91, 93, 94

Small Buds (page 14) — 91, 93

Looped Bullions (page 20) — 104

Tiny Petal Flowers (page 18) — 17, 104, 120

Blossom (page 20) — 16

Single Blossom Loop (page 20) — 16

Leaves (page 21) — 114

- Press embroidery face down on a towel when finished. Finish the bag as described on page 35/36.

CRYSTAL POWDER BOWL

This bowl is a Framecraft product available from quality craft and needlework shops. It is essential to work on fine fabrics otherwise mounting is too difficult.

The design worked is given below and is made up of daisies in white and pink (No 12) Silk Stitch, the bullions are wrapped eight times (page 18). Stems of lavender (page 21) and tiny rose buds (page 14) are worked with ten and nine wraps, using Silk Stitch Nos 170 and 140, tiny hanging flowers (page 19) are worked in Silk Stitch white and No 17, and greenery in Silk Stitch No. 161.

- To prepare the fabric, draw two circles on a sheet of paper, the larger one being the same size as the inside of the lid rim and the smaller one being the circumference of the design.
- Choose a fine fabric for the embroidery (the original is worked on silk dupion) and back it with thin pelon fleece or cotton fabric.
- Lay the paper pattern on the fabric and tack or machine around the inside circle first, then machine around the outer edge.
- Tear away the paper.
- Work a foundation of feather stitch around the design circle, then add some small side branches in feather stitch. Work the flowers, positioning the largest flowers around the circle first. Fill in with the smaller flowers to complete the design.
- Press the work face down on a towel.

I prefer to pull the fabric around the metal mounting disc provided, rather than cut it to the exact size of the lid as suggested in the Framecraft instructions. This removes all creases from the fabric and ensures that the fabric is firmly mounted, particularly as the perspex cover provided cannot be fitted over this type of embroidery. Proceed as follows:

- Trim the lining fabric right back against the outer ring of machine stitching, taking extreme care not to cut the outer fabric.
- Trim the outer fabric into a circle, allowing approximately 2 cm (¾″) outside the machine stitching.
- Using a very strong thread, dental floss is good, run a gathering thread 1 cm (⅜″) from the edge.
- Centre over the metal disc, pull up firmly and tie off securely.
- If you wish to use a fabric protector, apply at this time in accordance with the manufacturer's instructions and allow to dry.
- Push embroidery firmly into the lid and glue the covering disc to the back.

◯ Daisy (page 18) ≡ Leaves (page 21)

◊ Lavender (page 21) ⬯ Small Buds (page 14)

⚓ Hanging Flower (page 19)

Crystal Powder Bowl

LAVENDER BROOCH

This brooch is made with a Framecraft brooch mount that is available in gold or silver.

I recommend cutting a piece of fine iron-on vilene to the size of the frame and ironing it to the back of the fabric *before* working the embroidery. This prevents the fabric from wrinkling when mounted and also helps to hide ends of threads that might show through the finished work.

Centre the design carefully on the vilene shape.

When the embroidery is finished, press carefully and cut out the shape, using the vilene as a cutting guide. Frame in accordance with the manufacturer's instructions.

The design for the lavender brooch is given here:

- Couch the stems in place.
- Work lavender (see page 21).
- Make a tiny bow by couching looped bullion stitches in place.

Lavender Brooch Design

DECORATING READY-TO-WEAR CLOTHING

Suitable items of clothing can be hard to find, however, one soon gets used to looking for key design detail that can be used to advantage. Occasionally this can involve a slight alteration to a garment. For example the towelling robe pictured in the colour pages was

Daisy

originally a wrap-over style. By purchasing a size smaller than normally required and sewing in a heavy duty, open ended zip, the front panelling became an ideal place for embroidery.

The daisies are quick to work using San Remo five ply cotton knitting yarn, requiring just eight wraps for each petal. The quilted edging on the gown provides an ideal base for the embroidery. The actual size of each flower is shown here. They are scattered in groups of one, two or three flowers along the front panel and around the cuffs. The centres of each flower are colonial knots worked with two strands of stranded cotton in gold.

A collar already attached to a purchased garment can be worked to give an individual touch to what would otherwise be a fairly basic design.

The dress shown in the colour pages is treated in this way with three camellias worked in Silk Stitch No 169 as a bright touch to the plain white pique collar. Bullion loop leaves in Kanagawa 1000 No 114 complete the simple design.

Similar treatment can be given to the bodice, yoke or pockets of a dress, jacket or top.

The lovely handmade baby jacket was purchased with the attractively woven ribbons already in place. It was a very simple matter to add tulip-shaped flowers in each little 'window'. The flowers are worked in 'Au Vere a Soie' Soie D'Algere, using two shades of pink, Nos 911 and 2912, and green No 3714. Use four strands with ten wraps for the dark centre, three strands with twelve wraps for the lighter petals and three strands of green with ten and twelve wraps for the green base.

I hope these ideas will inspire readers to go in search of suitable projects to work on. Items of suitable babywear include vests, bibs, socks, bootees and grow-suits. Children's and adult wear can include T-shirt tops, knitwear, skivvies, sloppy joes, blouses, dresses and lingerie.

GIFTS FOR BABY

RABBIT DESIGN

If you are familiar with applique work you will no doubt have a favourite way of working. I recommend the following method as one of the easiest for beginners.

- Trace or photocopy the design, taking into consideration that the finished applique will be the reverse of the design on the paper.

- Position the traced design on the reverse side of the work and pin in place.
- Cover the applique area on the right side with the chosen fabric and pin in place, allowing ample coverage around the outer edges.
- With the wrong side of the work uppermost, and using a straight stitch, sew around the outline of the design through the paper and fabrics. Follow the outline of the design carefully, remembering that the smaller the stitch length used the easier it is to negotiate curves.
- Using a small pair of sharp embroidery scissors, trim away the excess applique fabric as close to the machine stitching as possible.
- Using a satin stitch setting on the machine, with the right side of the design uppermost, stitch carefully, working over the edge of the design. One of the many machine embroidery threads now available will give the best results for this stitching.
- Finally tear away the paper from the wrong side of the work. Working through the paper pattern keeps the fabric firm and wrinkle free and helps to keep the satin stitching even.

This method of applique also eliminates the use of bonding fabrics, which can result in stiff unpliable areas in the work.

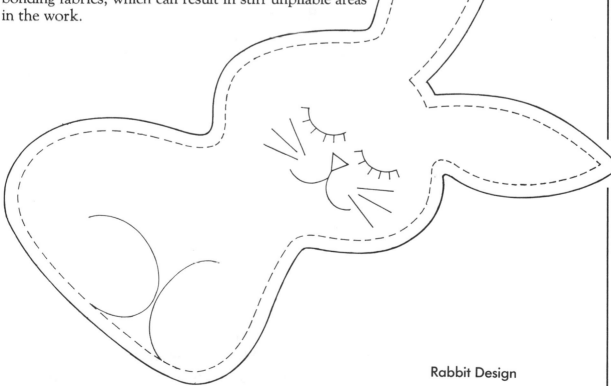

Rabbit Design

B •

centre line

Neckline
cut-out
pattern

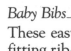

Baby Bibs

These easy-to-make bibs are very practical, with a snug fitting rib-knit finish at the neckline.

Use a fingertip towel, fringed if possible, to make one bib; or a larger towel to make several. This will give a wider choice of colours and thicker, better quality towelling than can normally be purchased by the metre.

Note that it is possible to fringe the woven band across the end of a towel by removing the crosswise threads of the band.

MATERIALS REQUIRED

1 piece of towelling: 29 cm wide x 42 cm long
(11.5″ x 16.5″)
Fabric for applique — flannelette or towelling scraps
1 piece of knit ribbing: 7 cm x 34 cm (2¾″ x 13½″)
60 cm (24″) ribbon for ties
Threads for embroidery

METHOD

- Cut a panel 29 cm x 42 cm from the towel, positioning the bottom of the bib on the fringe or along the base of the woven band.
- Fringe the band if necessary.
- Strengthen the fringed edge with zigzag stitch in matching thread across the top of the band.
- Mark the neck cut-out with a marker pen. Slit the centre back from A to B.

Note that it is important to stitch the following seams in the order given to keep the corners neat and reduce bulk as much as possible.

The raw edge is turned to the back and a zigzag stitch used to hold the hem in place and neaten the edge in one process.

- Stitch both side edges from C to D.
- Turn over the corner E to F and stitch; then trim close to the stitching line.
- Turn over the corners B to F and stitch; then trim close to the stitching line.

Trimming after stitching, when working on the cross grain, gives a neater hem.

- Applique the rabbit (see page 42).
- Cut out the neckline, fold the neckline ribbing in

half (right side together), insert the ribbon ties and stitch across the short ends.

- Turn the ribbing right side out and mark into quarters.
- Match these marks with the corresponding marks on the neck edge of the bib.
- Stretch the ribbing firmly and pin in place around the neck edge before stitching with an overlock stitch on your sewing machine or overlocker.
- Finish the bib with touches of embroidery as shown in the colour pages.

The original design is worked using the roses and rose buds, a cluster of three at the base of one ear and a collar of buds around the neck.

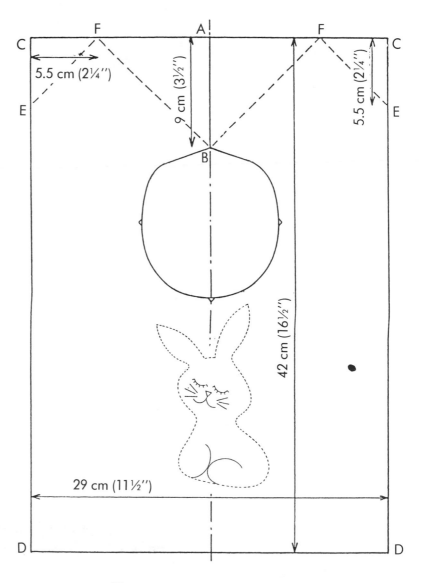

Baby Bib

*Toy Rabbit*_____

Worked in felt, this tiny rabbit is quickly assembled.

MATERIALS REQUIRED

Brown, fawn or white good quality felt:
18 cm x 24 cm. (7″ x 9½″)
Threads for embroidery
Small amount of fibrefill

METHOD

- Working as before, with the pattern transferred to paper, fold the felt in half and place the paper pattern on the back.
- Using matching thread, sew through paper and felt, leaving a small opening for stuffing at the base.
- Tear away paper and remove all remaining traces with a pin or needle.
- Cut out the rabbit, allowing a 2 mm seam allowance *outside* the machine stitching.
- Stuff firmly and close the opening with neat back stitching.
- Embroider features with stem stitch or couching and decorate one ear with roses or daisies. Decorate the neck with a narrow ribbon held in place with an embroidered flower.

 Use as a gift-wrap decoration, sew a safety pin on the back to make a brooch or hang two or three together as a mobile or crib toy.

*Cot Quilt*_____

Measurements: 76 cm x 61 cm (30″ x 24″)

MATERIALS REQUIRED

1.3 m (51″) cotton fabric 114 cm (45″) wide for front panel, edge binding and backing
15 cm (6″) batiste in each of four contrasting colours
62 cm x 77 cm (24½″ x 30½″) flannelette or similar for backing the front panel
62 cm x 77 cm quilt batting
Scraps of flannelette for rabbits
Embroidery threads, matching sewing thread

METHOD

- Cut a piece of flannelette or similar fabric as a base for the front section, making it the size of the finished quilt.
- Cover the bottom right hand corner with a triangle of fabric (see diagram).
- Cut or tear strips of fabric for the strip quilting, measurements are given on the diagram for the quilt shown in the photograph.
- Place the first strip over the edge of the triangular piece, right sides together and seam in place.
- Press the strip away from the triangle section. Pin the next strip over the raw edge and sew.
- Repeat until the base fabric is covered.
- Trim all the edges even.

Cot Quilt

- Applique rabbits, as given on pages 42-43, enlarging the pattern to twice the size for the big rabbit. (Many modern photocopiers have the facility to enlarge or reduce.)
- Embroider sprays of roses, daisies and tulip flowers along some of the diagonal strips and the features on the rabbits, using stem stitch or couching in grey on white rabbits and fawn or brown on brown rabbits. Work a collar of flowers and a decoration of flowers around one ear on each rabbit.
- Cut one piece each of backing fabric and quilt batting to fit the quilt front.
- Put all layers together, sandwiching the batting between the front and back sections.
- Starting from the centre of the quilt, pin and tack all layers together smoothly.
- Quilt by machine, using matching thread and working along the seam line of the strips and around the outline of the rabbits.
- Cut strips of border fabric 17 cm (7″) wide. Fold wrong sides together to form an 8.5 cm (3¼″) wide strip. Press carefully.
- Pin the raw edges of the strips to the right side of the quilt, 3.5 cm (1¼″) in from the edge.
- Stitch 4 cm (1½″) in from the quilt edge, the top and bottom edges first, then the side edges, folding in the ends at the corners where necessary.
- Hem the folded edges to the back of the quilt.

TEDDY BEAR

This teddy bear pattern can be used as illustrated, with a variety of laces forming a mock crazy patchwork design. Further decoration using bullion embroidery sprays creates an heirloom bear.

The pattern looks equally as effective in velvet with touches of embroidery on the ears and paws and a pretty lace collar.

Made in calico or homespun, without too much decoration, the bear can be used as a signature bear for a special occasion gift.

MATERIALS REQUIRED

Outer fabric and pellon fleece:
40 cm x 114 cm (16″ x 45″) makes one bear,
70 cm x 114 cm (27″ x 45″) makes two bears

Fibre fill stuffing

Scraps of ribbon, lace and entredaux if desired

2 snap on eyes, size 12 mm

4 good quality two-hole buttons

Lace for collar: 50 cm x 5 cm wide (20″ x 2″)

Extra-long doll making or upholstery needle

Very strong thread
(e.g. DMC Cotton Perle No. 5)

Contrasting fabric for foot pads
(suede was used on the original teddy)

METHOD

- Copy all the pattern pieces onto paper. Lace placement lines as used on the original are shown on each piece.

- Back the chosen fabric with pellon fleece and pin the pattern pieces to the fleece.

- Machine stitch the outline of each piece through the paper and fabric using a small stitch.

- Mark lace placement lines in the same way if required.

- Transfer the eye and limb placement marks to the right side of the fabric.

- Tear away the paper and cut the pattern pieces out carefully, just *outside* the machine stitching.

- Plan any lace placement carefully so that each strip covers the ends of the previous piece as it is sewn in place. Thread beading with ribbon as necessary as you work.

- Pin the lace and entredaux over placement lines and stitch in place, taking care not to pull the lace too tightly when sewing. Stretching the lace at this point

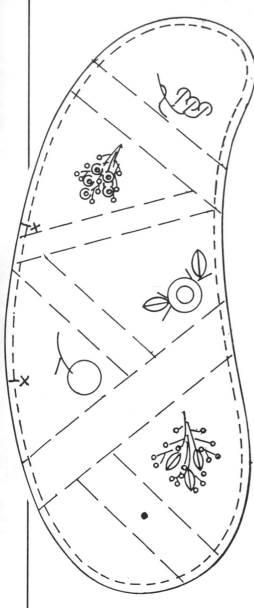

Arm

positioning of lace is
shown by broken lines

outer left drawn, inner
right similar

inner left and outer
right opposite

— cut two as drawn
— cut two opposite hand

may spoil the finished shape of the bear. Particular care should be taken when threading beading with satin ribbon as a tight strip of ribbon will not give as much as the fabric when stuffing the bear.

- Embroidery may be completed at this stage or, to gain more effective placement of the designs, when the individual pieces have been stuffed.
- Stitch all the darts in the side head panels.
- Place side head pieces right sides together and sew seam A-B.
- Match head gusset points C-A-C to side head sections C-A-C, tack into place and machine stitch carefully, using a small stitch.
- Join hand pads to the inside arm pieces.
- Stitch arms together, leaving open between X's for turning and stuffing.
- Stitch leg sections in the same way.
- Tack foot pads in place, right sides together, and stitch carefully.
- Stitch centre front body seam.
- Stitch centre back body seam, leaving open where the extra seam allowance is shown for turning and stuffing.
- Stitch front body to back body at side seams, matching the centre front and centre back seams at the base.
- Turn all pieces inside out.
- Secure eyes in position.
- Stuff pieces firmly and ladder stitch openings together securely.

Successful stuffing is an art and if well done gives the work a professional finish.

For the best results, always use good quality stuffing. Use a blunt tool, such as the handle end of a crochet hook or a screwdriver, to pack down small pieces of stuffing very firmly. You will be surprised how much can be packed into a small space. The use of an interlining when constructing the bear should make it easy to keep the surface of the bear smooth. A decorative bear of this type should be stuffed firmly so that it holds its shape over a period of time. This is particularly important if the bear is to be used as a signature bear.

- Finish the embroidery as required.

- Embroider the nose and mouth, working a triangle in satin stitch outlined in straight stitch for the nose and straight stitch lines for the mouth.
- Using strong thread, sew the head of the bear to the body very firmly, working in ladder stitch around the neck area at least twice.
- Attach the arms and legs as follows:

If the long needle will not fit through the button holes take a long double strand of strong thread and thread through the button, then thread the needle with one end of the thread and pass it through the limb and the body of the bear to the other side. Repeat with the other end of the thread. Leave threads untied while repeating the process to attach the other limbs.

Pull the threads very firmly and tie off securely, each limb being tied off on the opposite side of the body between the body and the opposite limb.

- Place ear pieces right sides together and sew around the curved edge. Turn inside out. Turn in a narrow hem along the base and pleat to shape into a slight curve before ladder stitching to the head from the head gusset seam down the dart stitching.
- Sew short ends of collar lace into a circle and run a gathering thread around the straight edge. Slip over the bear's head, pull up, adjust gathers and tie off securely. Tie a ribbon around to cover the edge of the lace.

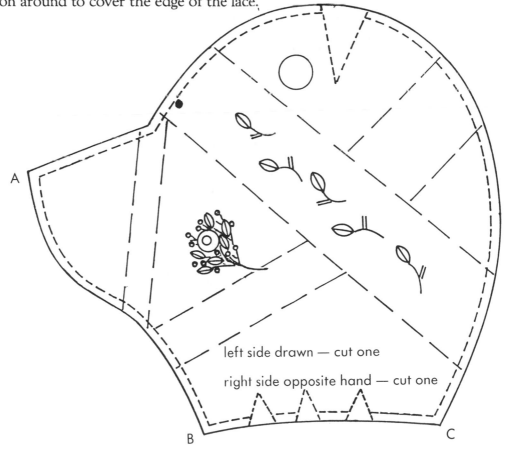

left side drawn — cut one

right side opposite hand — cut one

Head

examples of the decoration on the bear illustrated are shown in the patterns for the head, arm and leg

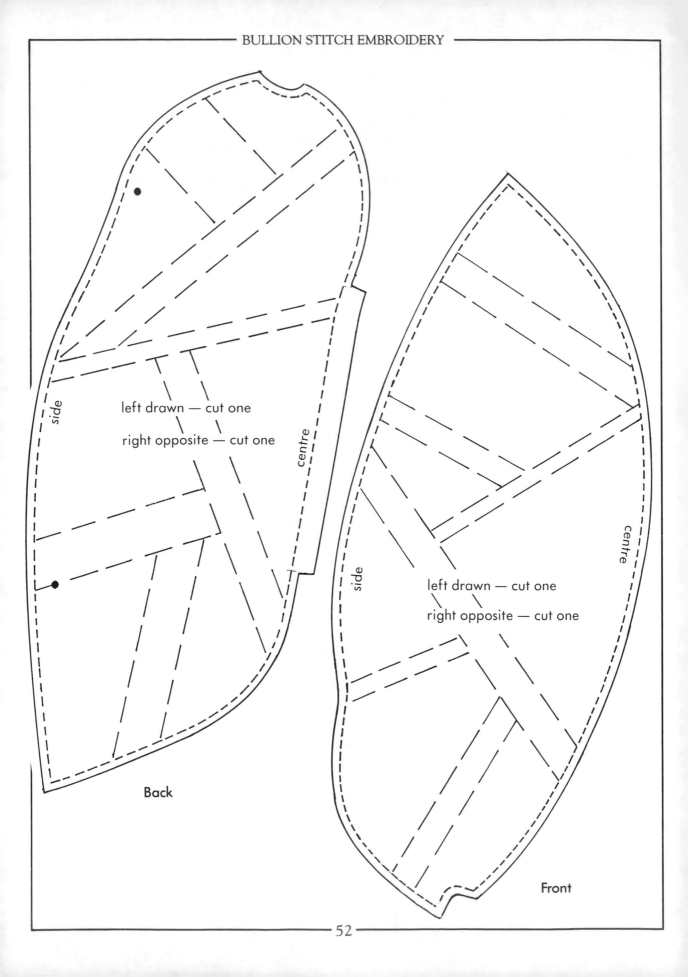

side

left drawn — cut one

right opposite — cut one

centre

Back

side

centre

left drawn — cut one

right opposite — cut one

Front

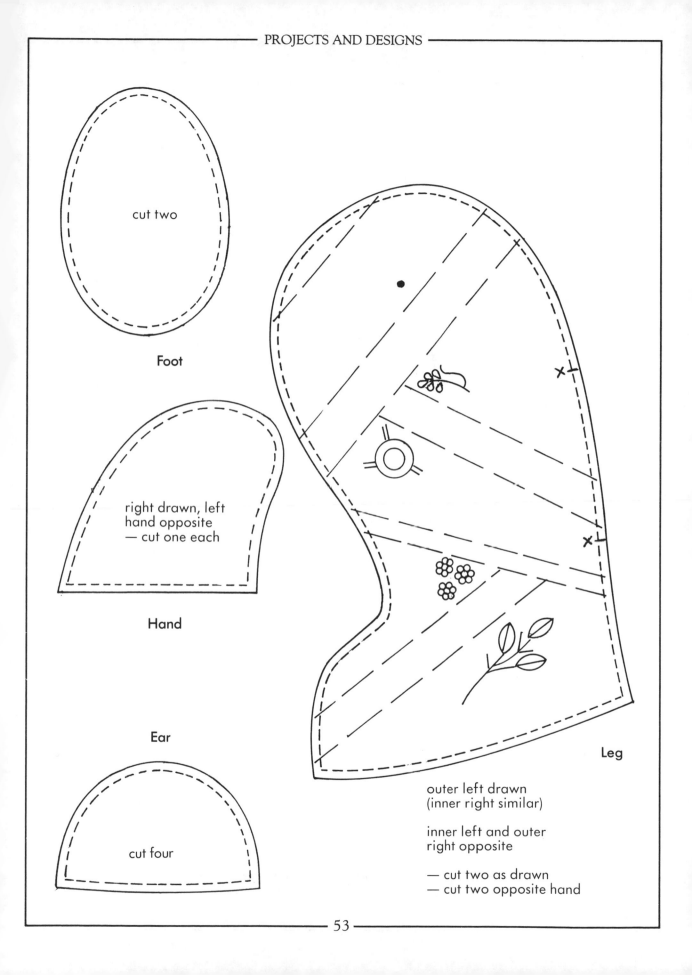

cut two

Foot

right drawn, left
hand opposite
— cut one each

Hand

Ear

cut four

Leg

outer left drawn
(inner right similar)

inner left and outer
right opposite

— cut two as drawn
— cut two opposite hand

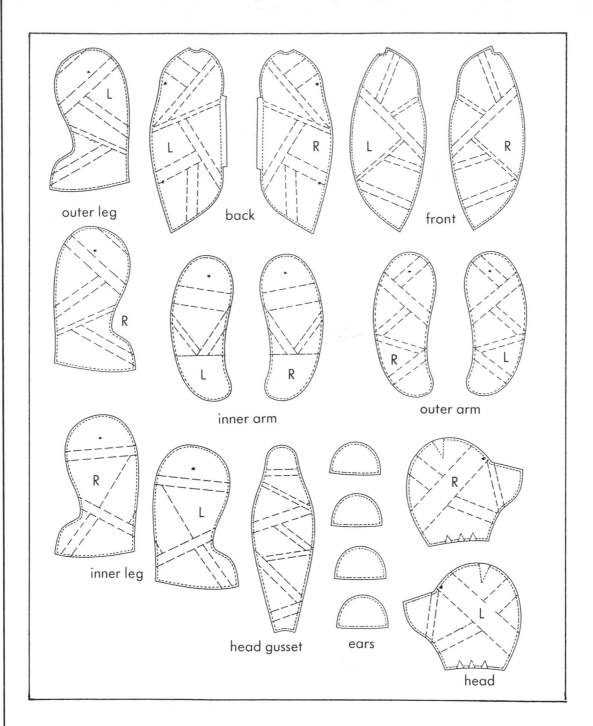

outer leg

back

front

inner arm

outer arm

inner leg

head gusset

ears

head

positioning of lace is indicated
for the bear as illustrated

¼ scale layout for cutting from
57 cm x 70 cm (22½'' x 27½'') material

Teddy Bear

hands and feet to be
cut from contrast material

COTTAGE GARDEN PICTURE

The finished size of the original embroidery is 10.5 cm x 15.5 cm (4″ x 6″). It is worked on canvas, nine threads to the centimetre or twenty-two threads to the inch. All stitching is done in stranded cotton, except for the bullion stitch flowers, which are worked in silk.

Shaded effects are obtained by mixing strands of threads of different colours. Alternatively there are various hand-dyed shaded embroidery threads available which can be used.

- Use four strands for all straight stitch areas, three for all colonial knots unless otherwise stated and single strands of silk thread for bullion stitches. Stranded cotton colour numbers quoted are for DMC brand.

- To work the picture, copy the design lines directly onto the canvas from the pattern on page 57. To make stitching easier, take care to line up as accurately as possible the vertical and horizontal lines on the pattern with the threads of the canvas.

- Place the canvas into a small tapestry frame for working.

Remember to spread the threads when working all straight stitches. Always 'strip the thread' for embroidery. Pull one strand at a time and then smooth them back together before threading the needle.

1. Work the sky, blending strands of mixed blues. Take the stitching across the tree area in the top right hand corner.

2. Work the thatch, mixing and blending the threads and using long and short stitch in section 2 and satin stitch in 2A. Vary the mixture of threads as you work.

3. Pad the chimney area with vertical straight stitch before working in horizontal straight stitch over three or four threads to form a brick pattern, blending the three colours. Fill in brick work on the right hand side of the front door.

4. Work stone work in vertical straight stitch, blending the threads.

5. Work long straight stitch to fill in wooden beams, working an 'X' stitch where they intersect under the window on the right hand side.

6. Work vertical straight stitch for the windows in 317, leaving one row of holes down the centre of each window. Using one strand of 762, work a diagonal criss-cross pattern, over the top of the straight stitch, into alternate holes of the canvas around the outside edge of each section of straight stitch. Straight stitch the window frames in 762. Straight stitch with 317 above the right hand windows.

7. Use vertical straight stitch, mixing 646 and 647, for the door. Work horizontal bands in 645 for hinges and handle. Work a bullion stitch to complete the handle. Outline the door with 646.

Diagram Number	Detail	Thread Numbers
1	Sky	827, 828
2 + 2A	Thatch	646, 612, 782
3	Brickwork	355, 356, 758
4	Stonework	841, 842, 543
5	Wood beams	646
6	Windows and window frames	317, 762
7	Door and door frame	645, 646, 647
8	Front steps	647, 543
9	Paving stones	762, 543
10	Stone work	841, 842, 543
11	Tree	3345, 3348
12	Shrub	3051, 3364, 341, 333
13	Bush	3051, 3365
14	Rose bush — flowers	Silk Stitch No 17
	— green	367, 368
15	Bush	319, 367
16	Hollyhocks — flowers	602, 604, 605
	— leaves	502, 319
17	Delphiniums — flowers	793, 794, 554 (blended)
	— leaves	502, 319
18	Window box — flowers	Kanagawa 1000 No 4
	— greenery	3012
19	Shrub	772, 445 (blended)
20	Bullion — flowers	Kanagawa 1000 No 169
	— greenery	3012, 3013
21	Daisy bush	white, 3072, 972
22	Purple flowers	208, 3012, 3013
23	Pink bush	893, 891, 367
24	Blue bush	793, 794, 368
25	Yellow daisy bush	743, 922, 895
26	Pink bullion flowers	368, Kanagawa 1000 No 93
27	Bullion loop flowers	Silk Stitch white, 161
28	Iceland poppies — background	3072
	— flowers	Silk Stitch Nos 16, 17, 113, 175
	— centres	green embroidery thread
29	Rose bush — flowers	Kanagawa 1000 No 4
	— greenery	3345, 3347
30	Border	603, 605, 320

Cottage Garden Picture

8. Work front steps, alternating single horizontal straight stitches in 543 with 647.

9. Paving stones are worked in 762, using a diagonal straight stitch and alternating the direction of the stitch for each paver. Outline each stone with a single strand of 543.

10. Stonework is worked in small long and short stitches over two to four threads, blending the colours.

11. Cover this area sparsely with colonial knots worked in two strands of 3345 or 3348 or one of each.

12. Fill the area with colonial knots, using two strands each of 341 and 333 for flowers and mixing 3051 and 3364 for greenery.

13. Work colonial knots using two strands and mixing the colours.

14. Work tiny bullion roses, using a colonial knot for the centre and three five-wrap bullion stitches for the petals of each flower. Note that when working bullion stitch on canvas it will be necessary to 'stab stitch' the bullion. Referring to the diagram on page 8, take the needle right through to the back of the work at point B (keep the thread on the surface), return the needle halfway through the canvas at point A, wrap the needle and finish as usual. Work some colonial knots as buds and cover the remaining area with green knots.

15. Fill with colonial knots, mixing the colours.

16. Cover the area with horizontal straight stitch in 319 before working variegated
17. flowers of colonial knots in pink or blue. Work long vertical stitches in 502 below the flowers for leaves.

18. Using red, work a row of bullion stitches along the base of the window. Cover the lower area with straight stitch leaves over the base of the bullions.

19. Fill with colonial knots, mixing 772 with 445.

20. Scatter bullion stitches over the area. Cover the canvas with straight stitch leaves.

21. Fill the area with colonial knots worked with three strands of 3072. Scatter white knots, using four strands over the green, and finish each white flower with a gold centre worked with a single strand of thread.

22. Cover the area with random straight stitches in 3012. Add flowers in colonial knots.

23. Work variegated flowers with four strands in colonial knots. Fill the area with
24. green knots, using three strands.

25. Work as for 21, using 895 for greenery, 743 for flowers and 922 for centres.

26. Work as for 20, using Kanagawa 1000 No 93 for flowers, No 368 for greenery.

27. Work looped bullion stitch, bell-shaped flowers in white and cover the remainder of the area with bullion stitch leaves.

28. Cover the area with horizontal straight stitch in 3072. Work bullion loop flowers with green colonial knot centres. Add bullion stitch stems and leaves to cover the area.

29. Work tiny bullion roses with red, starting each with a colonial knot. Fill the remainder of the area with colonial knots in green.

30. Fill the area with colonial knots in pinks and green.

PRETTY PACKAGING

Attractive packaging can add the final personal touch to a special gift. The following ideas are quick and easy and certain to add that special touch.

Velvet Heart Jewellery Pouch

MATERIALS REQUIRED

Each piece requires a 10 cm (4″)
square of fabric
2 squares of velvet
2 squares of lining fabric (lightweight)
4 squares of interlining — voile or muslin
Fine braid — 40 cm (16″)

METHOD

- Copy the heart pattern four times.
- Place one piece of interlining fabric with each velvet piece (right sides together) and one piece of interlining with each lining piece (right sides together).
- Position the pattern on each piece and sew right around the outline of each heart.
- Cut out the hearts, leaving a small turning *outside* the stitching line. Clip all curves carefully.
- Make a cut in the centre of the interlining fabric and turn right sides out through the slit.
- Press carefully.
- Embroider a tiny spray of flowers on one heart.
- Slip stitch the hearts together in pairs — one velvet, one lining.
- Sew the two hearts together, leaving the top curves open.
- Trim the seams with a narrow braid. Beginning on the left side of the opening, sew the braid across the front curves, around the base of the heart and back across the back top curves, making a loop at the centre back for the fastening.
- Sew a decorative button on the centre front.

Velvet Heart Jewellery Pouch

Hanging Flower (page 19)

*Fabric Covered Box*_____

This idea is based on the Origami method of paper folding to construct a small box suitable for jewellery or tiny gifts.

MATERIALS REQUIRED

Heavy paper — A 15 cm (6″) square will make a box top 5.5 cm (2¼″) square

A 14.5 cm (5¾″) square for the box base

1 piece of lightweight fabric to cover the top. Fine cotton or silk dupion is ideal

Spray adhesive

METHOD

- Lightly mark the diagonals, as shown in figure 1, on each square.
- Work the base of the box (smaller square) first.
- Fold the paper as shown in figures 2 to 4, pressing firmly along each crease. Open out flat (figure 5).
- Repeat this folding process on the other diagonal lines. Open out flat again (see figures 6 and 7).
- Cut carefully along the heavy lines as shown in figure 8.
- Re-fold the long sides, as shown in figure 9, turning the cut end sections at right angles to overlap each other across the remaining sides.
- Fold the remaining side sections to the inside of the box, over the overlapping sections to hold them in place.
- Cut a square of paper to fit inside the base and glue in place to hold the box together.
- Fold the larger square as before (figures 1 to 5).
- Cut a piece of fabric the same size as this square. Position it over the paper (figure 7) and carefully locate the centre square, which will be the box top, so that the embroidery can be accurately placed.
- Embroider a tiny spray of flowers within the lid area.
- Spray the paper square (ensuring that it is the correct way up to re-fold along the creased lines) with a *light* coating of spray adhesive.
- Attach the embroidered fabric square.

- Cut along the solid lines as before.
- Re-fold the box top as before, pressing the creases with a warm iron.
- Cut a fabric square to fit inside the lid and spray it lightly with adhesive. Press firmly into place.

Origami Box Design

Soap Bag or Pot Pourri Bag

Designed and made by Doreen Smith

- Cut a piece of calico or similar cotton fabric 16 cm (6¼") square.
- Work a small spray of roses in the centre of the square.
- With the design the right way up, seam the side edges together to form a tube.
- Fold the tube so that the seam is down the centre back and sew across the bottom edge.
- Turn a narrow hem around the top edge and finish with a narrow lace edging.
- Tie with narrow satin ribbons.

Christmas Crackers

(Designed for decoration or packaging, not pulling)

REQUIREMENTS (FOR 1 CRACKER)

1 piece of fabric: 60 cm x 23 cm (23½" x 9")

1 piece of gold or silver fabric:
10 cm x 23 cm (4" x 9")
or 23 cm (9") of 8 cm (3") wide ribbon

Ada band: 5 cm wide x 23 cm (2" x 9")

1 card tube from a toilet roll

2 pieces of medium-weight iron-on vileen:
7 cm x 23 cm (2¾" x 9")

METHOD

- Embroider a design in the centre of the ada band.
- Fold the short ends of the large fabric piece to meet in the centre, *wrong sides together*, and press firmly to crease.
- Position the iron-on vileen strips along the folds, extending away from the centre panel, and press.
- Bring the ends back to meet in the centre again, but with *right sides together*.
- Machine down each side seam.
- Turn right side out through the opening and press.
 Press a 1 cm (⅜") turning along each long edge of the gold or silver fabric and centre it across the outside of the prepared piece.

- Place the cardboard roll on the inside at one edge of the fabric and roll into a tube. Tie together with cotton around the centre.
- Wrap the ada band around the centre of the roll and sew in place at the centre back, over the join.
- Tie the fabric firmly with narrow satin ribbons at the ends of the tube.

CRACKER DESIGNS

Candles

- Using Kanagawa 1000 No 4 or 5, work three long bullion stitches (twenty-five to thirty wraps) and couch into place.
- Finish with green leaves (page 21) and tiny gold beads at the base.
- Work three ten- to fifteen-wrap bullions in gold-coloured thread (Kanagawa 1000 No 79) for the flame.

Candles

Bell

- Draw the bell shape onto the fabric.
- Outline with long couched bullion stitches in Kanagawa 1000 No 79.
- Work a colonial knot for the clapper.
- Using red Kanagawa 1000 No 4 or 5, couch looped and straight bullion stitches in place to form a bow at the top of each bell.
- Add green leaves and gold beads as desired.

Bell

Poinsettia

- Draw a circle for the centre of the flower.
- Use couched bullion stitch in Kanagawa 1000 No 4 or 5 to form five petals around the centre.
- Work five more petals in the spaces between these petals.
- Fill the centre with colonial knots, working the centre knots with two strands of yellow thread and the outside ring with one strand each of yellow and green.
- Add green leaves and beads as desired.

Poinsettia

EASY IDEAS FOR GIFTS

I would like to thank Jacky Kelly for designing and making the following items. Beautiful cotton laces and delicate roses worked in Marlitt thread have been combined to add a touch of sheer luxury.

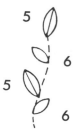

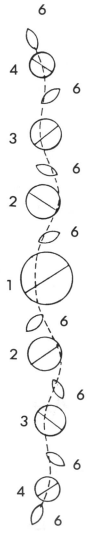

Coat Hanger

Two lengths of scalloped lace edging, approximately 8 cm (3″) in width, are seamed along the centre top to form a cover for a softly padded hanger covered in satin or taffeta.

Tiny roses are worked between each scallop, before catching the two lace edges together with tiny satin bows just below each rose.

Hand Towel

Two rows of lace, joined with a matching beading that has been threaded with satin ribbon, cover the lower edge of the towel.

The design worked across the woven band of the towel is detailed on this page, using six strands of Marlitt thread for the roses and three strands for the leaves and stem. The numbers of wraps used in the bullion stitches are noted on the design diagram; all unmarked stitches are 12 wraps. Work stem in green, finish with the roses — darker colour first.

6 5

4

- - - - - - green & darkest colour for roses

———— lightest colour for roses

3

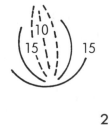

2

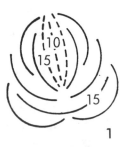

1

Hand Towel

Tissue Pack

MATERIALS REQUIRED

Voile or batiste, 1 piece: 8.5 cm x 17.5 cm (3½″ x 7″)

Matching lining fabric, 1 piece:
15 cm x 17.5 cm (6″ x 7″)

Lace edging with beading
approximately 4 cm (1½″) wide — 35 cm (14″)

Ribbon to thread beading — 80 cm (32″)

- Cut lace in half and sew to each long edge of the smaller piece of voile.
- Work small rose buds, or any tiny flowers, across the two short edges of this piece of fabric approximately 2.5 cm (1″) from the edge of the fabric.
- Finish the 17.5 cm edges of the lining piece with a rolled hem edge or tiny overlocking stitches.
- Centre the lining right sides together with the outer cover and sew along the short edges.
- Turn right sides out, pressing carefully.
- Slip stitch the lining to the cover along the open ends.
- Fold the sides to meet at the centre front and machine in place across each end.
- Cut the ribbon in half and thread through the beading at each end.
- Remove the wrapping from a pack of tissues and insert them with the cardboard backing into the cover and tie the ribbons into a bow.

SHORT CUTS FOR QUICK RESULTS

The design used on the front of the 'brag book' illustrates how ribbon leaves and lace flowers can be used to supplement a few bullion flowers to achieve quicker results.

The cardboard template kit was supplied complete with instructions by Helen Norton, of Creative Craft Kits, St Ives NSW.

This type of design is suitable for many items based on these template kits, including photo frames, box tops, book covers and greeting cards.

MATERIAL REQUIREMENTS
Embroidery threads
Guipure lace flowers (sold by the metre)
Fine narrow lace
Satin or silk ribbon, 2 or 3 mm wide

METHOD

- Work a grounding of feather stitch for the design.

- Make a large lace flower by gathering a strip of fine narrow lace into a circle. Position this flower in the bouquet, but do not sew at this stage (or the embroidery threads will catch around it as you work the bullion flowers).

- Mark the position for the remaining flowers, remove the lace flower and work the bullion stitch flowers.

- Make some ribbon leaves by cutting 1 cm (⅜") lengths of ribbon and folding as shown. Sew the leaves firmly across the base to the fabric, trimming the ends of the ribbon as required. Attach the leaves as you work so that the lace flowers cover the base of each leaf.

- Sew guipure lace flowers into position, working a colonial knot for the centre of each one. Guipure lace flowers can be coloured as required by painting with fabric paints.

- Replace the gathered lace flower and work a centre of colonial knots.

- Finish the design with a scattering of colonial knots in the background.

- Add a folded ribbon bow held in place with two bullion stitches.

- A tiny heart charm hangs from the bow on the original design.

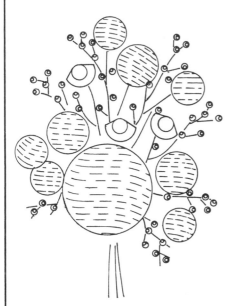

"Brag Book" Design

AUSTRALIAN WILDFLOWER DESIGNS

THE CLOCK

The clock pictured was made by my husband Don, details for woodworkers are given on page 68 (kits are also available through the author). The embroidery is worked sampler-style to display each of the flowers described on pages 22 to 33 and mounted on a padded plywood disc that is screwed into place.

The background fabric is a raw silk known as Noil silk and is available as a dress fabric. The actual size of each spray of flowers is given here, each one being worked as detailed in chapter 3.

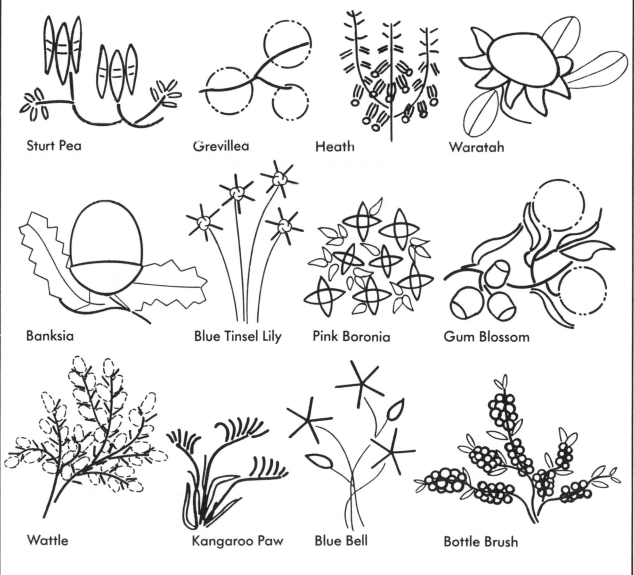

Sturt Pea Grevillea Heath Waratah

Banksia Blue Tinsel Lily Pink Boronia Gum Blossom

Wattle Kangaroo Paw Blue Bell Bottle Brush

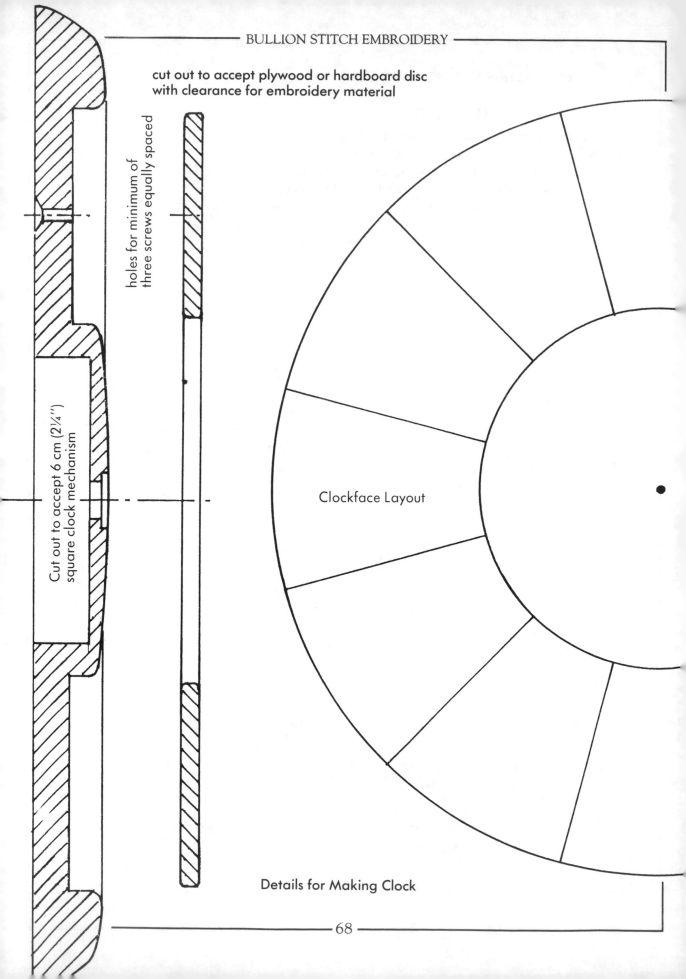

cut out to accept plywood or hardboard disc
with clearance for embroidery material

holes for minimum of
three screws equally spaced

Cut out to accept 6 cm (2¼″)
square clock mechanism

Clockface Layout

Details for Making Clock

- To prepare the fabric, transfer the outlines of the disc and the required division lines by machine, as detailed on page 5, backing the fabric with pellon fleece.

- Work the embroidery, taking care not to go too close to the machine-stitched guide lines, as the fabric will stretch a little when mounted.

- Trim away the pellon backing close to the outer edge stitching. Trim the outer fabric to leave a 2-3 centimetre (1″) turning *outside* this edge.

- Cut away the centre circle, leaving a similar turning allowance *inside* the inner marked circle.

- Clip this inner turning evenly around the circle to the machine stitched circle. Do not trim the interlining away on this edge.

- Cover the plywood template with a layer of thin wadding, cutting it flush with the edges of the disc.

- Position the fabric over the padded disc and, using strong thread, lace firmly in place, taking care to tension the fabric evenly as you work.

- The divisions between each section are covered with a very fine craft braid, stretched across the front and sewn in at the back.

GUM BLOSSOM PICTURE

The picture of red-gum blossom is worked on Noil silk and mounted over a disc of plywood. The velvet-covered surround can be made to fit a circular or oval frame in exactly the same way as described for mounting the clock embroidery.

The embroidery in the original design is worked in DMC stranded cotton in the following shades:

- Gum blossom: 349 & 350 mixed and 727; flower centres and new nuts: 522.

- Leaves: 522

- Centre vein: 524

- Outline: 301

- Gum nuts: 3032 & 3031

Working instructions for gum blossom and nuts are given on page 29.

Leaves in this design are worked in satin stitch, as described for waratah and banksia. Some leaves are outlined in green and others in brown 301.

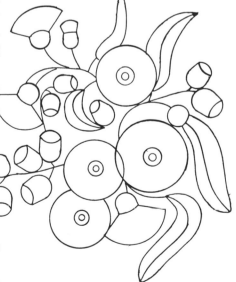

Gum Blossom Picture

CHATELAINE

This pretty design is very practical. Worn around the neck, it always keeps a small pair of scissors to hand. Pins can be stored around the edge of the disc. It is advisable to make this design washable as the neck strap will get soiled. With this in mind I recommend using plastic for the pin disc stiffening. Sheet plastic can be purchased from craft shops, or round templates used for plastic canvas embroidery are ideal.

MATERIALS REQUIRED

Fabric: 1 piece 100 cm x 7 cm (40″ x 3″);
1 piece 15 cm x 30 cm (6″ x 12″) for the disc

Plastic: 10 cm x 20 cm (4″ x 8″) or two plastic canvas discs approximately 8.5 cm (3¼″) in diameter

Wadding: 10 cm x 20 cm

100 cm lace beading threaded with ribbon (braid may be substituted), to decorate the strap

Embroidery threads for the chosen design

The illustrated design is worked in Silk Stitch, using the colours listed in chapter three for flannel flowers, boronia and bluebell.

- Cut the plastic, wadding and fabric as detailed on the pattern.

- Embroider the design on one piece of fabric.

- Run a strong gathering thread around the outside of the two fabric circles.

- Cover the plastic disc with the wadding; centre over the wrong side of the fabric circles. Pull up the gathering threads, check the design position and tie off threads firmly.

disc pattern

cut two each
plastic and wadding

 Flannel Flower (page 26)

 Blue Bell (page 25)

 Boronia (page 26)

- Prepare the strap by folding a turning along one short edge.
- With the right side of the fabric *outside*, fold the long edges to meet along the centre front of the strap. Press firmly.
- Trim the beading and thread with ribbon, leaving the ends long enough to attach the scissors at one end.
- Position the threaded beading down the centre of the strap, covering the raw edges. Tuck the end of the beading only to the inside at the fold on one end. Stitch in place down both edges and across the folded end. Making sure the ribbon ends are hanging free to attach the scissors later.
- Sandwich the unfinished end of the strap between the two covered discs and ladder stitch them together firmly with strong thread.
- Tie the scissors to the ribbon.

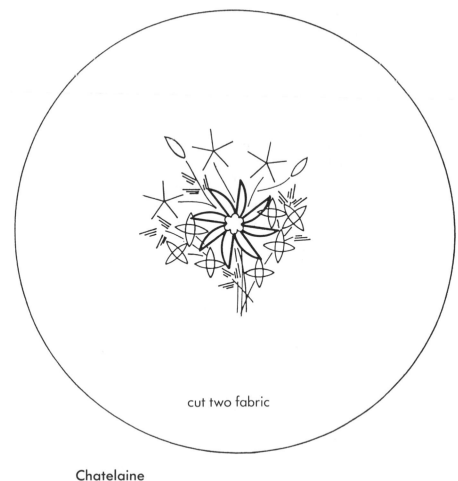

cut two fabric

Chatelaine

PLACE MATS AND NAPKINS

Made on an evenweave linen such as lugana, these are quick to work and easy to finish.

MATERIALS REQUIRED

Fabric

Place mats: 41 cm x 29 cm (16″ x 11½″) for 1 mat;

Napkins: 29 cm x 29 cm for 1 napkin

Embroidery threads

Cotton perle No 5 for weaving

Draw threads of the fabric to the required size before cutting to ensure straight edges and correct placement of the design.

Needleweaving has been used to add extra design detail to the plain fabric used for this project.

- Starting at the top left hand corner, measure 8 cm (3″) along the top edge. Remove one vertical thread from the fabric at this point. Skip two threads and remove the next one. Measure 8 cm down the side from the same corner and remove two horizontal threads in the same way.

- Using a tapestry needle and contrasting cotton perle thread, replace these threads by weaving over and under two at a time.

To ensure the point where the threads cross looks even, the first row in each direction should be started at this intersection.

- Press work thoroughly and trim the coloured threads level with the edges of the fabric.

- To finish the edges, first remove the *ninth thread* in from each edge.

- Using matching thread and a close zigzag stitch on the machine, stitch around the edge of the fabric, working over two or three threads *inside* the line of the withdrawn threads. Removal of the single thread first makes stitching easier to keep accurate and in line with the threads.

- Remove all threads outside the machine stitching to form a fringe.

- Work the embroidery in the top left hand corner. Designs from the clock are used on the original samples.

Any queries for the author should be directed to:
Jenny Bradford
PO Box 5
Scullin ACT 2614
Australia
Phone: (06) 254 6814 (AH)